T0293858

EDINBURGH'S LITERARY HERITAGE AND HOW IT CHANGED THE WORLD

Jan-Andrew Henderson

AMBERLEY

For Anita Sullivan

First published 2020

Amberley Publishing
The Hill, Stroud
Gloucestershire, GL5 4EP

www.amberley-books.com

Copyright © Jan-Andrew Henderson, 2020

Cover image: Jamie Corstorphine
Photographs by Jan-Andrew Henderson

The right of Jan-Andrew Henderson to be identified
as the Author of this work has been asserted in
accordance with the Copyrights, Designs and Patents
Act 1988.

ISBN 978 1 4456 9408 5 (print)
ISBN 978 1 4456 9409 2 (ebook)

British Library Cataloguing in Publication Data.
A catalogue record for this book is available from the
British Library.

Typesetting by Aura Technology and Software
Services, India. Printed in Great Britain.

Contents

Introduction

I don't wonder that anyone residing in Edinburgh should write poetically.

Washington Irving

Literary Edinburgh changed the world. That's a pretty bold claim, isn't it? Sure, Edinburgh boasts plenty of famous authors, was the first ever UNESCO City of Literature and hosts the largest international book festival on the planet. But changing the world?

Well, it did and I'm going to tell you how. But first, I'd like to clarify a few things.

When I say Literary Edinburgh, I don't just mean books. I also mean authors, journals, publishers, editors and, to some extent, the city itself. Together they created causal chains of events and influences that shaped the course of history. This book is partly the story of how it happened. It's also a tribute to the many writers and publications involved (some lauded, some forgotten) and the roles they played. Lastly, it's a guide to the landmarks and attractions that give their presence lasting physical form – from birthplaces to gravestones. My house is in it too, as I live in hope.

If there's one reoccurring theme, it is how often revolutionary ideas born in Edinburgh were so ahead of their time, they failed to make a splash until long after they were written. But what an impression they eventually made.

I've put everything in chronological order and picked one representative book from each writer – though, as I said, it was occasionally the people, rather than their works, which made the biggest impact.

So, let's go on a journey through time and discover the weird and wonderful life of Literary Edinburgh.

1. Once Upon a Time

Edinburgh started small, beginning as a collection of rude dwellings perched on a basalt ridge, with a sorely needed fortification at the top. Originally home to warring Pictish and Celtic tribes, the Romans invaded during the first century and Anglo-Saxon Northumbrians in the seventh century. When the town eventually came under the rule of the Scots in the tenth century, writing wasn't exactly at the forefront of a rural community more concerned with surviving than getting in touch with their inner muse.

As evidence of that, the first truly influential work in this book doesn't appear until the fourteenth century and, initially, didn't seem to be particularly significant. In fact, it took centuries before its true worth was realised.

1320: The Declaration of Arbroath

In 1314, King Robert the Bruce (1274–1329) defeated the English at the battle of Bannockburn and set Scotland free from its neighbour's yolk. Despite this, Edward II of England (1284–1327) still considered himself Scotland's overlord. So, Bruce swapped sword for pen, commanding the Declaration of Arbroath be drawn up and signed by his bishops and nobles. It was a plea to Pope John XXII, asking him to recognise Scottish Independence, arguing that Bruce couldn't go on the crusades, like a good Christian, if he was still resisting aggressive southern forces. The Pope didn't fall for this blatant propaganda piece but what it actually says is astonishing for the time:

> Yet if he [Bruce] should give up what he has begun, and agree to make us or our kingdom subject to the King of England or the English, we should exert ourselves at once to drive him out as our enemy and a subverter of his own rights and ours, and make some other man who was well able to defend us our King.

Scotland's monarch had added his name to a document agreeing he was only the nation's leader because it chose him – the Scots could pick another if he betrayed their cause. It may have been a bluff, but setting the wishes of the people above their ruler was an utterly radical statement in an era when the divine right of kings was unquestionable. Then it was pretty much forgotten for 400 years.

Those with sharp eyes will notice it's called the Declaration of Arbroath, so where's the Edinburgh connection? That came in the eighteenth century, when the 'Scottish Enlightenment' was in full swing and Edinburgh had become a world leader in just about any area you care to name. (Don't worry, you'll read plenty about that later.)

Meanwhile, American colonies were fighting to free themselves from Britain's stranglehold and seeking inspiration for their own statement of autonomy. This fledgling democracy had the ancient Greeks and England's Magna Carta as touchstones,

but Edinburgh's Enlightenment thinkers weren't shy about pointing out how the Declaration of Arbroath perfectly fitted the bill – especially its most famous passage:

> It is in truth not for glory, nor riches, nor honours that we are fighting, but for freedom - for that alone, which no honest man gives up but with life itself.

When, in 1776, the Founding Fathers penned the American Declaration of Independence, the Declaration of Arbroath had become a powerful template – with some serious Caledonian backing. Many southern Scots had risen to positions of power in North America and almost half the signatories of the Declaration of Independence were Scottish or of Scots descent. Benjamin Franklin (1705–90), one of the USA's Founding Fathers, stayed at the Edinburgh home of the philosopher David Hume, while the third president, Thomas Jefferson (1743–1826), claimed Robert Bruce as an ancestor.

US Senate Resolution 155 even states the US declaration was modelled on Bruce's document. As such, a hitherto obscure tract played a crucial role in shaping the most powerful nation in the world.

Anyone who was a supporter of Donald Trump would do well to read both again.

Landmarks: The National Archives of Scotland, Princes Street, contains a copy. There is also a statue of Bruce outside Edinburgh Castle.

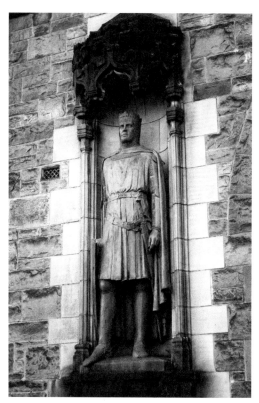

Statue of Bruce, Edinburgh Castle.

2. Sixteenth Century: Divine Inspiration

By the sixteenth century, Edinburgh was the capital of Scotland and a thriving city. It was also embroiled in religious turmoil. Catholicism had long been the dominant force but dissatisfaction was growing with an increasingly corrupt clergy, whose doctrines and actions were out of touch with the populace. Protestantism was spreading across Europe and, though the Highlanders stuck to the old religion, Southern Scotland began to embrace this new movement. Since Scots never shy from a good barney, a cycle of dreadful violence quickly ensued, with Catholics burning Protestants as heretics until the Protestants had gained enough power to persecute them back.

Naturally, contemporary literature reflected this preoccupation. Nothing unusual about that, as the clergy was one of the few select groups who actually knew how to read and write. Unfortunately, religion was pretty literal back then when it came to matters of good and evil – about the only thing Catholics and Protestants agreed on. The Devil was real, with horns and everything. Demons existed. Witches had warty noses and cursed people. What we now call superstition was taken as absolute fact and Edinburgh writers couldn't leave the topic be, even when tackling other subject matters.

1508: *The Complaint of the Black Knight* by John Lydgate (dates unknown)
Walter Chepman (*c.* 1473–*c.* 1538) and Andrew Myllar (1503–1508) established Scotland's first printing press in 1508 and this is, supposedly, the first volume they printed. Written by an English monk, it's a love narrative with inevitable supernatural overtones, sometimes falsely attributed to Chaucer.

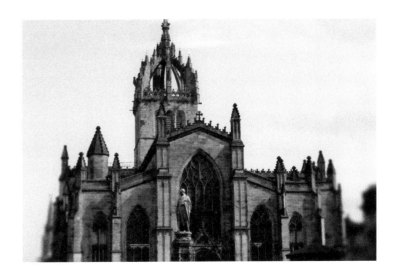

St Giles' Cathedral,
Royal Mile.

Landmarks: The press was located at the bottom of Blackfriars Street and Chepman has a plaque and aisle in St Giles' Cathedral on the Royal Mile. There is a copy of *The Complaint of the Black Knight* in the National Library of Scotland on George IV Bridge.

c. 1565: *The Historie and Chronicles of Scotland* by Robert Lindsay of Pitscottie (1532–80)

This was the first history of the country to be written in Scots, rather than Latin, presenting scenarios we'd now consider fantastical as real events. It recounts how the Devil appeared at the Mercat Cross in Edinburgh in 1513, predicting the Scots were about to be massacred at the Battle of Flodden (it happened). Scots armies getting trounced by the English was all too common, but adding a demonic element to the story was a dangerous road to take. Edinburgh's fascination with the supernatural would eventually lead to misery, persecution, and, in the end, one of the most important books ever written.

It was a preoccupation that never really went away, as we shall see.

Fun Fact: The *Historie* wasn't properly published until 1728, almost 200 years after it was penned.

Landmarks: The Mercat Cross is outside St Giles' Cathedral, though it was originally further down the street. Maybe that's why the Devil never seemed able to find it again.

1558: *The First Blast of the Trumpet Against the Monstrous Regiment of Women* by John Knox (1513–72)

The person most responsible for tipping the balance of power from Catholicism to Protestantism in Scotland, John Knox returned from exile to become minister of St Giles' Cathedral in 1559.

The First Blast of the Trumpet is a misogynistic and offensive book by modern standards (or any standards, really) arguing that female rule challenged the God-given authority of men over women – who are weak, foolish and cruel by nature. It was a handy rant to aim at the newly crowned Mary, Queen of Scots (1542–87), who had the misfortune to be both Catholic and a woman. This book – and his fiery sermons – helped turn public opinion against Mary, who was eventually driven from Scotland, then imprisoned and executed by her cousin, Elizabeth I of England (1533–1603). Mind you, it didn't stop Knox marrying a seventeen-year-old when he was fifty.

Knox is the perfect example of a writer who had much greater influence as a person. Though he isn't read these days, he set a chain of events in motion with far-reaching consequences. He insisted all children, rich or poor, should have an education, so that they could read religious texts themselves, rather than have God's word interpreted by priests. It resulted in southern Scots developing an education system far superior to other nations, essentially laying the foundations for the Enlightenment. This turned out to be a massive own goal for Knox, for educated people question things, like the fundamental tenants of organised religion.

Above: John Knox burial place, St Giles' car park.

Right: John Knox statue, St Giles' Cathedral.

There would be a hard-fought battle for the minds of a country where the clergy held a chokehold on every aspect of society. But, when they finally arrived, Enlightenment thinkers probed, challenged, then finally defeated the authoritarian dominance of religion in Southern Scotland.

Fun Fact: Knox spent ten years in chains, rowing a French galley ship, which probably didn't help his sour temperament much.

Landmarks: Knox lived in what is now known as John Knox House on the Royal Mile, though there is debate about whether that's actually true. Many historians claim the story was made up to stop the place getting demolished in the nineteenth century and, in Edinburgh, myth always triumphs over fact – which is a pretty fine literary tradition. Knox was buried in St Giles' Graveyard, now a car park, and has a plaque on bay 23 – though there's usually a Honda covering it. Besides, he was moved when the bodies were excavated and relocated to Greyfriars Kirkyard. Exactly where his remains lie now is anyone's guess.

1579: *De Jure Regni Apud Scotos* by George Buchanan (1506–82)

Buchanan's treatise is a companion in sentiment to the Declaration of Arbroath. Its doctrine states the source of all political power is the people and it is lawful to resist and even punish tyrants. The importance (and danger) of this work was borne out by persistent efforts to suppress it. The tract was condemned twice in acts of parliament and

George Buchanan's grave, Greyfriars.

burned by the University of Oxford. But Buchanan put his money where his mouth was. Tutor to Mary, Queen of Scots, he eventually accused the monarch of complicity in the murder of her husband, helping to depose her.

Landmarks: There is a statue of Buchanan in Princes Street Gardens. He is buried in Greyfriars Kirkyard and has a memorial stained-glass window in the kirk.

1597: *Daemonologie* by James VI (1566–1625)

James Stewart was the son of Mary, Queen of Scots. Succeeding to the throne of Scotland at thirteen months, he was moulded into a good Protestant by a series of regents. Though a decent king, he developed an obsession with witchcraft which would be considered paranoid by today's standards. With *Daemonologie*, James set out to prove that black magic existed and recounted the trials of dozens of local 'witches' he suspected were trying to kill him. On the king's orders, many were tortured until they confessed and

Witches' Well, Edinburgh Castle esplanade.

Edinburgh Castle.

named a bunch of accomplices, fuelling James' fixation even more. They were then burned on Castlehill in the Lawnmarket.

Edinburgh was already rife with superstitious lore and James helped cement its status as a dark and midnight place. This was a reputation that never went away and I believe it eventually influenced some of the world's most famous horror stories.

Fun Fact: James anonymously wrote a tract on the evils of tobacco, thinking a reasoned argument would persuade the populace to give it up. When nobody paid attention, he pragmatically re-released it under his name and banned smoking instead.

Landmarks: James was born in Edinburgh Castle and its esplanade contains the Witches' Well, a small monument to the many innocents falsely accused of being in league with the Devil.

1599: The Oldest Surviving Masonic Minutes in the World

Adding to Edinburgh's secretive reputation was its association with the Knights Templar and the city's prominent role in the birth of Freemasonry. The oldest surviving Masonic minutes in history are kept in the oldest Masonic lodge still existing in the world – the Lodge of Edinburgh, Mary's Chapel, No. 19 Hill Street.

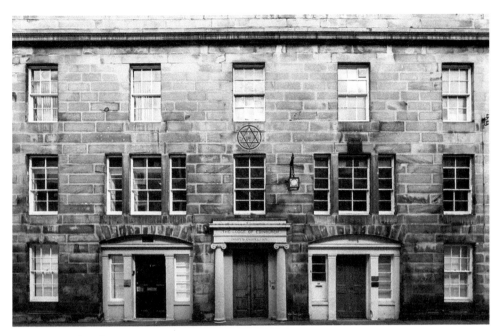

Mary's Chapel, Hill Street.

Other Works of Note

1503: *The Thrissil and the Rois* by William Dunbar (1459–*c*. 1530)
Dunbar was a poet in the court of James IV, and his writings were included in the Chepman and Myllar prints of 1508, the first works to be printed in Scotland.

1513: *Eneados* by Gavin Douglas (*c*. 1474–1522)
Bishop Gavin Douglas' major literary achievement was a Scots translation of Virgil's *Aeneid* – the first successful example of its kind in any Anglic language. He helped organise the Treaty of Rouen, renewing the 'Auld Alliance' between France and Scotland, which held firm for another two centuries. Born in Tantallon Castle, just outside Edinburgh, he became parson of Lynton (now East Linton).

3. Seventeenth Century: Divine Retribution

In 1606, Elizabeth I of England died without an heir and James VI of Scotland became James I of England, taking off for London and never coming back. During the centuries they ruled Scotland, the Stewart monarchs were never shy about initiating fisticuffs with their southern neighbours, but you'd think a union of the crowns would put paid to all that nonsense.

You'd be wrong.

Though James was popular enough, his headstrong descendants were to cause a century of civil war in Scotland and England and bring about their own downfall. Once again, this wasn't a great atmosphere for Edinburgh literature to thrive – and most important works were mainly polemics and religious tracts. However, there were a few major surprises along the way and (of course) some pulpy, sensationalist warnings about the paranormal. The first, and most acclaimed, is considered high art. Plot wise, however, it's a bit of a potboiler, contains the usual paranormal elements and was directly inspired by James.

1606: *Macbeth* by William Shakespeare (1564–1616)
The play is about a real Scottish king who ruled from 1040 to 1057, though Shakespeare played fast and loose with historical facts. Duncan wasn't murdered and Macbeth was a well-liked monarch who ruled for seventeen years, most of them peacefully. Shakespeare wasn't just being lazy about research, however. He had a definite political agenda and *Macbeth* was an attempt to curry favour with the new king. The ghosts were a no-brainer, given James' fixation with the supernatural, while the witches act as if they came straight out of *Daemonologie*. More importantly, the character of Banquo was an ancestor of James, so the play pays homage to the Stewarts' royal lineage, reinforcing their right to rule in turbulent times – a sentiment the new king heartily supported.

In essence, one of the most important works in English literature is an act of brilliant sucking up to an Edinburgh-born monarch.

1611: *The King James Bible*
Macbeth may be a cornerstone of world literature but James trumped it in the most spectacular fashion. A new revision of the Bible had already been suggested by English clergymen but the king was quick to make the project his own, personally approving a list of revisers and monitoring their progress.

Did it change the world? Since it became the most widely printed book in history, guiding the actions of millions, I'll take that as a resounding yes.

1614: *Mirifici Logarithmorum Canonis Descriptio* by John Napier (1550–1617)

Amongst all this religious argy-bargy, Edinburgh's first great logical thinker appears, like a ray of sunshine. Napier was one of the finest mathematicians of all time and his writings were world-changing. Among other achievements, he was the discoverer of logarithms and made common the use of the decimal point in mathematics.

Landmarks: Napier was born in Merchiston Tower, now part of Napier University. He was buried in St Giles' Kirkyard (which meant he ended up in Greyfriars, like John Knox). He also has a memorial at St Cuthbert's Kirkyard on Princes Street.

1683: National Covenant

By the late seventeenth century, Protestantism was the prevailing force in southern Scotland and England. (The highlands remained staunchly Catholic and would stay pretty much a no-go area for another century.) However, trouble was brewing, for the English were Anglican and the Scots Presbyterian. Poor, wet, cold and backward, Scotland was looking for something to invest a bit of pride in. So, as usual, we took things too far and became even more fanatical about religion. Things came to head when James' son was crowned. Charles I (1600–49) was probably a secret Catholic but couldn't foist that on anyone. However, Anglicanism was closer to Catholicism than Presbyterianism, so he decided *that* should be the religion of Scotland.

It didn't go well. The first reading of the Anglican prayer book, in St Giles' Cathedral, resulted in a riot which quickly became a rebellion.

In 1638, Edinburgh's Presbyterians drew up a mission statement for their movement called the National Covenant and signed it in Greyfriars Graveyard. Its purpose was similar to the *Declaration of Arbroath*. The 'Covenanters' promised to support Charles I, as long as he didn't mess with their church. If he did, they felt justified in getting rid of him. Charles didn't listen and the Covenanters rose up in arms.

What followed is a fascinating but complex story, which I don't have space to tell, so thank goodness for Google. Here's a vastly simplified version.

The overbearing and despotic king had little sympathy in England, where the 'Parliamentarians' also rebelled – beginning the English Civil War. Charles was defeated with Covenanter assistance and the Parliamentarian leader, Oliver Cromwell (1599–1658), executed him.

Despite years spent fighting their tyrannical ruler, even the staunchest Presbyterian took this as a national affront. In Edinburgh's Parliament Square, the Covenanters proclaimed Charles I's young son to be King Charles II (1630–85). Mind you, they didn't want him turning out like his father, so the Covenanter leader, the Marquess of Argyll (1607–61), kept the young man a virtual prisoner until he had been shaped into a decent Protestant. Talk about history repeating itself.

Cromwell retaliated by invading and occupying Edinburgh, forcing the would-be monarch into exile and wrecking the town. As dictatorial as he was puritanical, Cromwell's eventual death left a void that the re-establishment of the monarchy was primed to fill.

Martyr's Monument, Greyfriars.

So, Charles II returned from the Continent and, determined never to be a pawn again, set about crushing the dispirited and fractured Covenanter movement.

Yet, there was a knock-on effect that nobody foresaw. The persecution of the Covenanters resulted in a massive exodus of Presbyterians to the USA, where it became the dominant form of religion in a much larger and more powerful country.

I'm calling it the 'Knox On' effect.

Fun Fact: According to legend, some signatories of the Covenant used their own blood rather than ink.

Landmarks: St Giles' Cathedral in Parliament Square houses a copy of the National Covenant. Huntley House on the Royal Mile contains another copy. The Covenanters' Prison is a walled section of Greyfriars Graveyard where Presbyterians were imprisoned in terrible conditions. It was, in effect, one of the world's first concentration camps. There is also a monument to the Covenanters there, as well as one in the Grassmarket.

1643: The Solemn League and Covenant by Alexander Hamilton (c. 1583–1646)

This was a later agreement, whereby the Covenanters promised to support the English Parliamentarians in return for England becoming Presbyterian. At least, that's how the Scots saw it. Once they had helped defeat Charles I, the English reneged on the deal,

Grave of Alexander
Hamilton, Greyfriars.

causing some Covenanters to pledge allegiance to Charles instead, irreparably fracturing their movement.

Landmarks: The headstone of Alexander Hamilton is in Greyfriars Graveyard and you can still see musket holes where English soldiers used it as target practice.

1650: *Lines Written on the Eve of His Execution* by James Graham, Marquis of Montrose (1612–50)

The Marquis of Montrose was a founder of the Covenanter movement, along with the Marquis of Argyll. But Montrose felt things had gone too far when the Scots went to war with their own king and switched sides, scoring several victories for Charles I, before being defeated and captured. He wrote this beautifully gruesome poem on the window of his cell before being hanged, drawn and quartered outside St Giles' on the orders of Argyll. Ironically, Argyll was executed on a same spot by Charles II.

> Let them bestow on every airth a limb
> Then open all my veins, that I may swim
> To thee, my Maker, in that crimson lake,
> Then place my par boiled head upon a stake;
> Scatter my ashes, strow them in the air.
> Lord, since thou knowest where all these atoms are,
> I'm hopeful thou'lt recover once my dust,
> And confident thou'lt raise me with the just.

Par boiled head? You can't beat that for poetic imagery.

Landmarks: The tombs of Montrose and Argyll are in St Giles' Cathedral.

Left: Montrose Memorial, Chepman Aisle, St Giles' Cathedral.

Below: Argyll Memorial, St Giles' Cathedral.

Other Works of Note

1613: *Teares on the Death of Moeliades* by Sir William Drummond (1585–1649)

A fine pastoral poet, Drummond attended the Royal High School and graduated from the recently founded University of Edinburgh. He has a burial vault in Lasswade Kirkyard.

4. Late Seventeenth Century: Things Get Spooky

After Charles II died, his brother James II (1633–1701) ascended the throne – but it was feared he intended to bring his son up a Catholic. In 1689, he was deposed and replaced by the Protestant Hanoverian William I (1650–1702). This turn of events wasn't appreciated over the border so, as part of an appeasement process, William re-established Presbyterianism as the official 'Church of Scotland'. Its authority was massively watered down and older adherents looked fondly back on the good old days, when they could burn old women for making potions from frogs. Yet, it still had bite and it would be decades before a new wave of clergy began to soften the Church's 'iron fist' approach to their flocks.

Fanaticism dies hard and the Covenanters never got their head round the idea that 'God's Chosen People' had failed to make all of England into glumsville. Surely evil forces must have conspired against them? Yeah, it was probably unnatural influences at work.

Add the fact that the Scottish capital was still medieval in outlook and you had the makings of a sinister mythology that still persists. Contemporary writings only strengthened this idea and even the city's main rival, Glasgow, jumped on the bandwagon.

1682: Founding of the Advocates Library

The library was begun by the King's Advocate, Sir George Mackenzie (1636–91), who had actually defended witches at trial. Then he did an about-face, persecuting and killing hundreds of Covenanters for Charles II, on the flimsiest of evidence. That's lawyers for you. In 1925 it became the National Library of Scotland.

The Covenanters' Prison, Greyfriars.

Above: Covenanters' Prison gates, Greyfriars.

Left: George Mackenzie mausoleum, Greyfriars.

Greyfriars Graveyard.

Fun Fact: As well as seven million works (including every book published in Scotland), the National Library has a First Folio of Shakespeare.

Landmarks: The National Library is on George IV Bridge. Mackenzie lived around the site of the Radisson Blu Hotel on the Royal Mile and has a large mausoleum in Greyfriars Graveyard, reputed to be haunted because he could never rest in peace after the atrocities he committed. The 'Mackenzie Poltergeist' reputedly haunts the Covenanters' Prison.

c. 1683: Pandæmonium, or the Devil's Cloister Opened by Richard Bovet (born *c.* 1641)

This virulently anti-Catholic tract repeated many fanciful tales about spooky Edinburgh, including the Fairy Boy of Leith, who led the 'Little People' on dances at Calton Hill. Its full title tells you all you need to know. *Pandaemonium, or, the Devil's cloyster being a further blow to modern sadduceism, proving the existence of witches and spirits, in a discourse deduced from the fall of the angels, the propagation of Satan's kingdom before the flood, the idolatry of the ages after greatly advancing diabolical confederacies, with an account of the lives and transactions of several notorious witches: also, a collection of several authentick relations of strange apparitions of dæmons and spectres, and fascinations of witches, never before printed.*

Try fitting all *that* on a cover.

1685: Satan's invisible world discovered: or, a choice collection of modern relations: proving evidently, against the atheists of this present age, that there are devils, spirits, witches by George Sinclair (d. 1696)

Written by the first Professor of Mathematics at Glasgow University but published in Edinburgh, this bestseller firmly established the city as a capital of weird.

Two of its tales are still famous. One is the story of Major Thomas Weir, a Presbyterian preacher who admitted to being in league with the Devil and was subsequently burned at the stake. The other is Mary King's Close, a street whose inhabitants were walled up after an outbreak of plague, turning it into a haunted hot-spot. There's absolutely no evidence that the walling up or supernatural manifestations happened – but it didn't matter then and, apparently, still doesn't. MKC is now open to the public and has a fiercesome haunted reputation to this day.

Landmarks: Though the original buildings are gone, what is now Victoria Street was the home of Major Weir. The Real Mary King's Close on the Royal Mile, under the City Chambers, is a popular visitor attraction.

Mary King's Close, Royal Mile.

1688: *The Kingdom of Darkness* by Nathaniel Crouch (born *c.* 1632)

Creepy stories about Edinburgh were picked up and widely retold in ultra-popular books, like the sensationalist *The Kingdom of Darkness.* For people desperate to cling to the idea that unseen hands threatened them, Edinburgh seemed to provide irrefutable proof.

Ironically, the city itself was about to take a very different literary path and reinvent itself. But this ghostly legacy would rear its head, time and time again.

Other Works of Note

1699: *Provision for the Poor in Time of Dearth and Scarcity* by Robert Sibbald (1641–1722)

Sibbald was the first Professor of Medicine at the University of Edinburgh. He was appointed Geographer Royal, founded the Royal College of Physicians and created the original Edinburgh Royal Botanic Gardens.

Fun Fact: The Blue Whale was originally named after Sibbald, which impresses the hell out of me. Shame it was later changed to *Balaenoptera musculus.*

Landmarks: Sibbald Walk on the Royal Mile is named after him and he is buried in Greyfriars.

Sibbald's grave, Greyfriars.

Botanical Gardens.

Sibbald Walk, Royal Mile.

5. Early Eighteenth Century: Forward or Backwards?

At the beginning of the eighteenth century, Edinburgh looked like it might be on a path to cultural insignificance. Stern religion still held the masses in its grasp, theatre was virtually banned (note the lack of plays referenced in this book) and literature wasn't exactly flourishing. The country was bankrupt as a result of the Darien scheme – a disastrous attempt to launch a trading post on the Isthmus of Panama, invested in by a huge portion of the population. In return for financial aid, England proposed the countries be united and the Scottish parliament dissolved – an idea abhorrent to most Scots. When, in 1707, the Treaty of Union was ratified, the poet Robert Burns wrote bitterly, 'We're bought and sold for English gold.'

An exodus of the rich and entitled to the south followed and the capital seemed set to end up a minor player in international affairs. Yet Scotland had kept its own legal and educational system, superior to its European counterparts, while the union proved to be a blessing in disguise.

Edinburgh was split between those who felt they should make the best of things and others who wanted to keep a northern identity. Both had one thing in common – a big chip on their national shoulders, leading to a 'we'll show them what we can do' attitude.

Scotland began to pull itself up by the bootstraps, eager to prove its worth. It was to become known as the 'Scottish Enlightenment' and Edinburgh emerged as its powerhouse. So much so, it is often called the 'Edinburgh Enlightenment'.

As part and parcel of this, the first shoots of literary greatness began to sprout, led by some truly remarkable characters.

1725: *The Gentle Shepherd* by Allan Ramsay (1686–1758)

Allan Ramsay established himself as a wig maker (as you do), before producing splendid poetry in the Scots vernacular. He then became a bookseller and editor, creating Britain's first circulating library and publishing works he had collected, designed to keep people in touch with their older national literature. His pastoral writing, including *The Gentle Shepherd*, is still widely lauded. In 1736, he founded a theatre in Carrubber's Close, which was closed after pressure from the clergy, who frowned on activities like acting and smiling. But he had set the ball rolling and it couldn't be stopped.

Landmarks: Ramsay's house, the 'Goose Pie', is still standing in Ramsay Gardens, Castlehill, and he has a statue in Princes Street Gardens. His shop was one of the 'Luckenbooths' (long-demolished stalls around St Giles' Cathedral). He is buried in Greyfriars Graveyard.

Alan Ramsay's House, Ramsay Lane.

Left: Alan Ramsay statue, Princes Street Gardens.

Below left: Ramsay's grave, Greyfriars.

Below right: Famous people buried in Greyfriars.

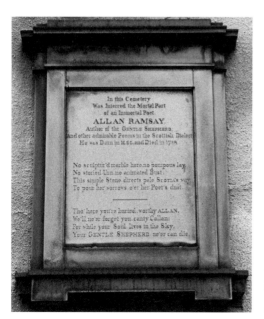

In this Cemetery
Was Interred the Mortal Part
of an Immortal Poet.
ALLAN RAMSAY.
Author of the GENTLE SHEPHERD,
And other admirable Poems in the Scottish Dialect
He was Born in 1686, and Died in 1758.

No sculptur'd marble here no pompous lay,
No storied Urn no animated Bust;
This simple Stone directs pale Scotia's way
To pour her sorrows o'er her Poet's dust.

Tho' here you're buried, worthy ALLAN,
We'll ne'er forget you canty Callan;
For while your Soul lives in the Sky,
Your GENTLE SHEPHERD ne'er can die.

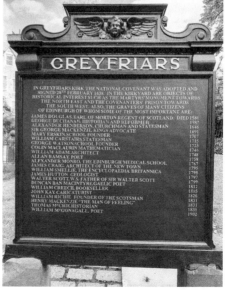

GREYFRIARS

IN GREYFRIARS KIRK THE NATIONAL COVENANT WAS ADOPTED AND
SIGNED 28TH FEBRUARY 1638. IN THE KIRKYARD ARE OBJECTS OF
HISTORICAL INTEREST SUCH AS THE MARTYRS' MONUMENT TOWARDS
THE NORTH EAST AND THE COVENANTERS' PRISON TOWARDS
THE SOUTH WEST: ALSO, THE GRAVES OF MANY CITIZENS
OF EDINBURGH OF WHOM SOME OF THE MOST IMPORTANT ARE:-
JAMES DOUGLAS, EARL OF MORTON REGENT OF SCOTLAND DIED 1581
GEORGE BUCHANAN, HISTORIAN AND REFORMER 1582
ALEXANDER HENDERSON, CHURCHMAN AND STATESMAN 1646
SIR GEORGE MACKENZIE, KINGS ADVOCATE 1691
MARY ERSKIN SCHOOL FOUNDER 1707
WILLIAM CARSTAIRS STATESMAN 1715
GEORGE WATSON SCHOOL FOUNDER 1723
COLIN MACLAURIN MATHEMATICIAN 1746
WILLIAM ADAM ARCHITECT 1748
ALLAN RAMSAY POET 1758
ALEXANDER MONRO, THE EDINBURGH MEDICAL SCHOOL 1767
JAMES CRAIG, ARCHITECT OF THE NEW TOWN 1767
WILLIAM SMELLIE, THE ENCYCLOPAEDIA BRITANNICA 1795
JAMES HUTTON GEOLOGIST 1797
WALTER SCOTT W.S. FATHER OF SIR WALTER SCOTT 1799
DUNCAN BAN MACINTYRE GAELIC POET 1812
WILLIAM CREECH BOOKSELLER 1815
JOHN KAY CARICATURIST 1826
WILLIAM RITCHIE, FOUNDER OF THE SCOTSMAN 1831
HENRY MACKENZIE "THE MAN OF FEELING" 1831
THOMAS McCRIE HISTORIAN 1835
WILLIAM McGONAGALL, POET 1902

1738: *A Treatise of Human Nature* by David Hume (1711–76)

Here comes the man who launched the Enlightenment properly and is, quite rightly, regarded as one of the greatest minds of all time. A particular hero of mine, he was an all-round good guy, tolerant, even-handed and eminently likable. He had no time for the inflexibility of the Church and was a self-confessed Atheist – an extremely dangerous position to hold in those days. In a series of books, he argued that there is no permanent 'self', redefined the relationship between cause and effect and altered our perception of human nature. Hume influenced utilitarianism, logical positivism, the philosophy of science, early analytic philosophy, cognitive science and a whole host of other major philosophers.

Emmanuel Kant said Hume awakened him from 'dogmatic slumbers', while Schopenhauer claimed 'there is more to be learned from each page of David Hume than from the collected philosophical works of Hegel, Herbart and Schleiermacher taken together'.

If you ever read them, you'll wholeheartedly agree.

Fun Fact: Hume was sarcastically branded as living in 'St David's Street' by a minister friend (yes, he had them). The name stuck.

Landmarks: Hume has a statue on the Royal Mile (wearing a toga, which I doubt he ever really donned). Supposedly born in Buchanan's Close, he also lived in James' Court and Riddle's Court in the Old Town, before moving to St David's Street in the New Town. He has a small plaque there and a large mausoleum in Old Calton Cemetery.

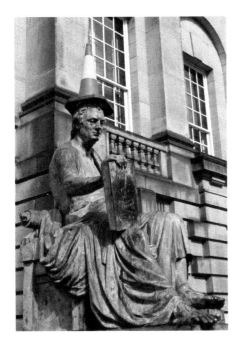

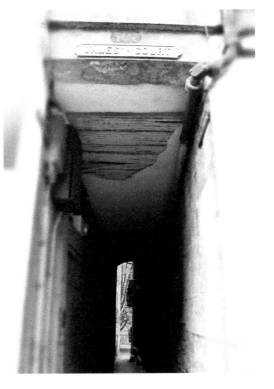

Above: Statue of David Hume, Royal Mile.

Right: James' Court, Royal Mile.

 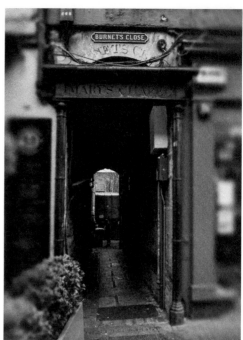

Above left: Hume's mausoleum, Old Calton Graveyard.

Above right: Burnet's Close, Royal Mile.

1739: First publication of *The Scots Magazine*

Edinburgh's literary journals are often overlooked, which is a shame, for it's possible they had a greater influence than the books produced in the city. The best-selling *Scots Magazine*, for example, is the world's oldest magazine still in publication.

Landmarks: The first issues were produced in Burnet's Close on the Royal Mile.

1745: Prince Charles Edward Stewart Tries to Reclaim the British Throne

All right, this is an historic event. Bear with me though.

Charles Stewart landed in Scotland, raised a Highland army, and tried to take back the throne from the Hanovarians. Edinburgh wasn't even on his side, though he took the city without a shot being fired. Spurred on by doomed ambition, he marched on London, reaching Derby, before reluctantly turning back in the face of overwhelming English forces. His men made a heroic last stand at Culloden and were annihilated. Charles fled back to France and the Highlanders faced persecution that was almost genocidal.

From this sprang the legend of 'Bonnie Prince Charlie' and a romanticized view of the Highlands that grew with each year. This was of huge significance to later Scottish writers, who were only too willing to perpetuate the idea that an arrogant and overreaching young man was really a national hero – and the rest of the world bought into an, essentially, manufactured myth.

It wasn't the last time either.

6. Late Eighteenth Century: The Enlightenment Blooms

The seeds sown by John Knox finally came to fruition: the floodgates opened and the capital exploded into a frenzy of creation. Edinburgh was still tiny and cramped, so the rich and poor rubbed shoulders, each enthused by the other, all willing to talk about what life and society really meant. The result was electric. By the end of the century, the city led the world in science, medicine, law, engineering, philosophy, trade, exploration, architecture, art and, of course, literature. This prestige was only enhanced by the eventual building of a magnificent New Town, causing it to be labelled the 'Athens of the North'.

Its influence on the rest of the world, especially the West, cannot be overstated, while the thinkers it produced became the social, philosophical and cultural backbone of the greatest empire of all time.

There were men who attempted to keep an authentic 'Scottish' voice and identity. They were matched by those who simply prized the acquisition of knowledge and the advancement of science – a heady mash-up that produced astonishing results. The following are just some of the publications and people who reinforced this incredible transformation.

1754 onwards: *Lectures on the Elements of Chemistry* by Joseph Black (1728–99)

Black pioneered thermodynamics, discovered magnesium, bicarbonates, latent heat, specific heat and carbon dioxide. He was Professor of Medicine and Chemistry at the University of Edinburgh where he lectured for over thirty years.

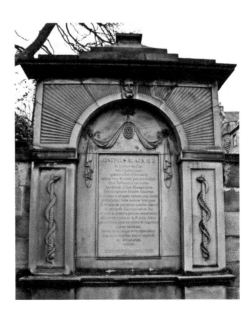

Joseph Black Memorial, Greyfriars.

Landmarks: Black lived in College Wynd and is buried in the Covenanters' Prison. The chemistry building at the University of Edinburgh is named after him.

1756: *Douglas* by John Home (1722–1808)

Home was a Scottish minister, soldier and author whose blank verse tragedy was hugely popular in Britain. A cod historical romantic epic about how cool Scots once were, it remained a standard Scottish school text until the Second World War. Unfortunately, old-style religion still held enough sway in Edinburgh for Home to be hounded by Church authorities until he resigned from the Ministry. But the Church's grasp on the populace was inexorably slipping, aided by a new wave of clergy who rejected their dogmatic inflexibility.

Fun Fact: On the opening night of *Douglas,* a member of the audience famously voiced his appreciation by yelling 'Whaur's yer Wullie Shakespeare noo?'

Landmarks: *Douglas* was first performed at the short-lived Canongate Theatre in Old Playhouse Close and a small bronze plaque stands near the site of his home on Maritime Street in Leith.

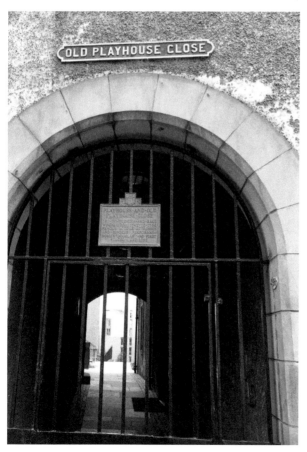

Old Playhouse Close, Royal Mile.

c. 1760: Moladh Beinn Dòbhrain by Duncan Ban MacIntyre (1724–1812)

MacIntyre is one of the most renowned proponents of Scottish Gaelic poetry, which flourished in Scotland during the eighteenth century, partly as a backlash against those who had adopted English speech and mannerisms.

Landmarks: MacIntyre lived in Roxburgh Close, where a plaque celebrates him. He is buried in Greyfriars.

1761: Fragments of Ancient Poetry collected in the Highlands of Scotland translated by James Macpherson (1736–96)

The name says it all really. Macpherson was an Edinburgh teacher who claimed to have collated ancient poetry he acquired from Highland clans. Encouraged by its reception, he finally produced and translated a set of epic writings by the third-century bard Ossian, to great commercial and critical success. Translated into many languages, these were instrumental in bringing about the Romantic literary movement in Europe and are certainly very erudite works.

However, Macpherson never produced the originals and it's now widely accepted that he made most of it up. Despite this, there is a lingering perception that Scotland had a flourishing epic tradition in antiquity, which helped cement the view of the Highlands as a land of 'noble savages' – an idea warped into near fairy-tale status by nineteenth-century writing. Throw in the exploits of Bonnie Prince Charlie and you have a romantic legend that came to typify how the world now sees Scotland. It was a view Edinburgh was only too happy to perpetuate though, for most of their history, its inhabitants hated the Highlanders and never ventured north if they could avoid it.

1767: An Essay on the History of Civil Society by Adam Ferguson (1723–1816)

'The Father of Modern Sociology', Ferguson's critically acclaimed essay enjoyed an international readership. It influenced Karl Marx and was taught in the University of Moscow, leading Voltaire to praise Ferguson for 'civilizing the Russians'. It was also a huge influence on American Republicanism. I'm betting Donald Trump never heard of it.

Landmarks: Ferguson was Professor of Natural Philosophy, then Moral Philosophy at the University of Edinburgh. He regularly entertained many of the leading figures of the Scottish Enlightenment at his house in No. 3 Sciennes, at that time on the edge of the city. Because of its remoteness, friends jokingly referred to it as 'Kamchatka' after the peninsula in Siberia. That kind of joke emphasises how erudite they all were.

1768–71: The Encyclopaedia Britannica by William Smellie (1740–95)

Edinburgh's first great editor, Smellie edited the *Scots Magazine*, then the *Encyclopaedia Britannica*, writing many of the entries himself. This is the daddy of all encyclopaedias, in print for 244 years and still available online. Smellie's *Philosophy of Natural History* led to him being described as a precursor of Darwin. He's not the only one, as we will see.

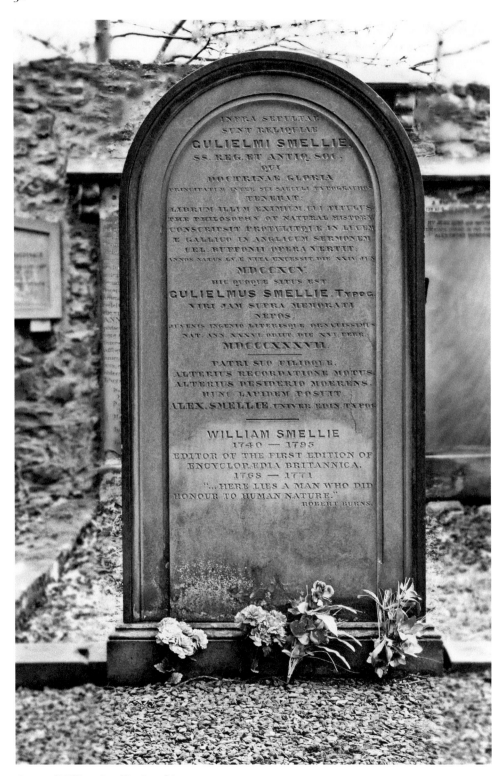

Grave of William Smellie, Greyfriars.

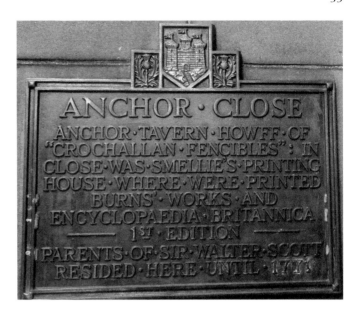

Anchor Close, Royal Mile.

Landmarks: The Encyclopaedia was first printed in Anchor Close on the Royal Mile. Smellie was born at the Pleasance and educated at Duddingston School, then Edinburgh High School. He is buried in Greyfriars.

1773: William Creech Establishes His Bookshop and Printing Works

William Creech (1745–1815) was the pre-eminent publisher of the eighteenth century, taking over Allan Ramsay's shop in the Luckenbooths, which soon became known as Creech's Land. As well as becoming Lord Provost (the Scottish equivalent of Mayor), he helped launch Robert Burns to stardom. Along with Smellie, Creech was instrumental in Edinburgh becoming famous as a book-printing centre. By the nineteenth century, it was a publishing behemoth, as others built on their experience.

Fun Fact: In 1788, Creech was a member of the jury in Deacon William Brodie's trial for robbery (*see* Robert Louis Stevenson). Within days, his account of the trial and execution went on sale in his bookshop.

Landmarks: Creech attended Dalkeith Grammar School and is buried in Greyfriars.

1773: *Of the Origin and Progress of Language* by James Burnett, Lord Monboddo (1714–99)

This is a largely forgotten work and few people appreciate its influence. James Burnett was a high court judge and a founder of modern comparative historical linguistics, with an interest in just about everything – and a tendency to believe some of the wilder stories he heard (he thought children were born with tails, which midwives secretly cut off). Certainly, Burnett was gullible, but that allowed him to make leaps of logic others wouldn't countenance. His great work, *Of the Origin and Progress of Language*, introduced a notion

decades ahead of its time. In it, he argued that man was descended from lower orders – a prototype theory of evolution.

This blasphemy didn't earn him the condemnation that might be expected, for Monboddo was such an oddball, he was simply ridiculed. Many years later, however, a young student studied medicine at Edinburgh, where Monboddo's crazy ideas were still well known. He obviously didn't find them so odd.

His name was Charles Darwin.

Fun Fact: Despite Edinburgh clergy's opposition to the stage, Monboddo was a proprietor of the Canongate Theatre. He became pals with David Hume, who was a principal actor in one of the plays. I love David Hume.

Landmarks: Monboddo lived at No. 13 St John Street in Edinburgh's Old Town. He is buried in an unmarked grave in the enclosure of Patrick Grant in the Covenanters' Prison.

Lord Monboddo's grave.

Radisson Blu building – site of the homes of Lord Monboddo and George Mackenzie.

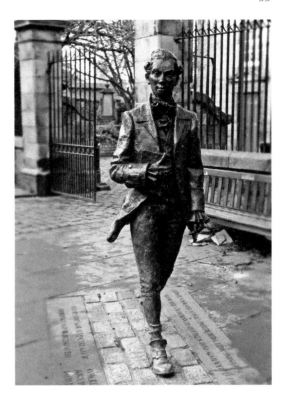

Robert Fergusson statue, Canongate.

1773: *Auld Reekie* by Robert Fergusson (1750–74)

Fergusson was a hugely talented young poet, who contributed greatly to the revival of Scots verse and pioneered a stanza known as the 'Standard Habbie'. His promising career was cut short when he succumbed to alcoholism and depression, dying after falling down a flight of stairs at the age of twenty-four. The Standard Habbie was then made famous by the man who Fergusson inspired: Robert Burns.

Fun Fact: Though Burns paid for Fergusson's headstone, Walter Scott also greatly admired him and was going to make it even fancier. Unfortunately, he died before he got round to doing so.

Landmarks: Fergusson is buried in Canongate Kirkyard, with a statue right outside. A plaque was erected in his memory in St Giles' Cathedral.

1776: *An Inquiry into the Nature and Causes of the Wealth of Nations* by Adam Smith (1723-90)

One of the titans of the Enlightenment, Adam Smith is known as the 'Father of Economics'. Like so many Edinburgh giants, he was an all-rounder, writing immensely influential tracts on morality, justice, social psychology and many other subjects. But the *Wealth of Nations* cemented his fame as the 'inventor' of Capitalism, which remains the world's dominant economic model.

Adam Smith's House (on the right), Canongate.

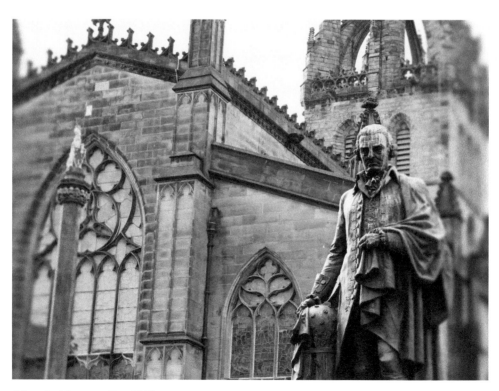

Adam Smith statue, Royal Mile.

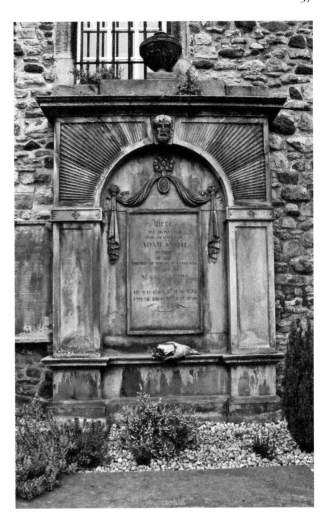

Adam Smith's grave, Canongate
Kirkyard.

Landmarks: Smith has a statue next to St Giles' and his house in St John Street, Royal
Mile, still stands. He is buried in Canongate.

1788: *Auld Lang Syne* by Robert Burns (1759–96)

The 'National Poet of Scotland', Burns needs no introduction. Abandoning life as a
tenant farmer, he moved to Edinburgh and quickly became the toast of the town. Burns
was canny enough to predict his handsome ploughman persona might become a fad
(it did), and figured he would have more longevity writing lyrics for songs than poetry.
He succeeded on both counts. Despite an early death, he became an inspiration to the
founders of both liberalism and socialism and one of the world's most famous poets.
Auld Lang Syne is still sung across the world on New Year's Eve.

Fun Fact: Burns once met fifteen-year-old Walter Scott in Sciennes House, the home of
philosopher Adam Ferguson. It is commemorated by a plaque in Sciennes Road.

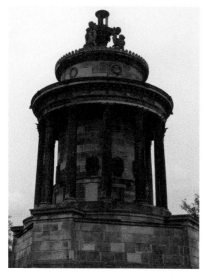

Left: Burns Monument, Calton Hill.

Below: Robert Burns statue, Scottish Portrait Gallery.

Landmarks: He is one of three greats celebrated in the Writers' Museum in Lady Stair's Close and stayed near the spot – commemorated by a plaque on Lawnmarket. There are dozens of closes on the Royal Mile, with associations to Burns, who really got around. You can see a full list in my book *The Royal Mile: A Comprehensive Guide*. He has a monument on Regent Road (the statue inside was moved to the Scottish National Portrait Gallery) and another statue in Bernard Street, Leith.

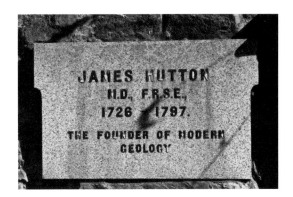

James Hutton's plaque, Covenanters'
Prison, Greyfriars.

1788: *Theory of the Earth* by James Hutton (1726–97)

James Hutton was a Scottish farmer and the 'Founder of Modern Geology'. Moving to
Edinburgh, he eventually produced his masterwork, which proved the earth took millions
of years to form, in direct opposition to biblical teachings. This was a huge inspiration for
Charles Darwin, backing up the controversial theories he was formulating.

Landmarks: Hutton used the rock formations of Arthur's Seat and Salisbury Crags as
evidence for his concepts. He is buried in the Covenanters' Prison in Greyfriars, where he
has an insultingly small plaque.

1791: *The Life of Samuel Johnson* by James Boswell (1740–95)

After travelling the continent, where he met Rousseau and Voltaire, Boswell became
friends with the irascible Samuel Johnson (1709–84), author of *A Dictionary of the English
Language.* Boswell's book was instrumental in establishing the biography as a genre and
many consider it the finest example of the form in the English language.

Boswell's Court, Royal Mile.

Landmarks: Boswell was born in the area of what is now Parliament Square and dined in Boswell's Court on the Royal Mile with Johnson. He also lived in James' Court. Johnson's visit to Edinburgh is commemorated with a plaque at the joining of Boyd's entry and St Mary's Street.

1793: *Outlines of Moral Philosophy* by Dugald Stewart (1753–1828)

Dugald Stewart's real fame was as a lecturer and he was principally responsible for making the 'Scottish Philosophy' predominant in nineteenth-century Europe. A brilliant polymath and gifted philosopher, he was appointed Edinburgh University's Professor of Mathematics at the age of twenty-five, then Professor of Moral Philosophy. Stewart had a huge impact on the western world, attracting students from England, Europe and America in numbers that had never been seen before – including two future prime ministers (Lord Palmerston and Lord Russell). He made Adam Smith famous by giving lectures on his seminal book *The Wealth of Nations* and his contributions to linguistic theory are regarded as a turning point in the history of the subject.

Landmarks: Stewart lived at No. 5 Ainslie Place in the New Town and has an impressive memorial on Calton Hill. He is buried in Canongate.

Dugald Stewart Memorial, Calton Hill.

Canongate Cemetery.

1798: The Founding of Thomas Nelson and Sons

Thomas Nelson was an Edinburgh publisher whose innovations were far-reaching. He pioneered the idea of sending out sales reps, while his son, Thomas Nelson Jnr, invented the rotary printing press, revolutionising the industry.

Fun Fact: The rotary press was never patented, so Nelson's loss became everyone else's gain, as it was copied across the world.

Thomas Nelson's grave,
Grange Cemetery.

St Bernard's Well,
Stockbridge.

Landmarks: Thomas Nelson and Sons began in the West Bow, before moving to Hope Park, then the edge of Holyrood Park. Nelson senior has a monument at St Bernard's Well, Stockbridge, and is buried in Grange Cemetery.

Other Works of Note

1771: *The Man of Feeling* by Henry Mackenzie (1745–1831)
Mackenzie championed Walter Scott, Robert Burns and Lord Byron and *The Man of Feeling* was one of the inspirations for the romantic novel. He lived at No. 6 Heriot Row, New Town, and is buried in Greyfriars.

1771: *The Expedition of Humphry Clinker* by Tobias Smollett (1721–71)
Smollet was a Scottish surgeon, poet and author. This satirical comedy was inspired by one of his last visits to Scotland, where he stayed with his sister at No. 22 St John's Street.

St John's Street, Royal Mile.

1773: *She Stoops to Conquer* by Oliver Goldsmith (1728–74)

This satire expertly explores divisions between city and countryside, men and women, and rich and poor. Goldsmith lived in Old Assembly Close on the Royal Mile while he studied medicine at the University of Edinburgh.

1791–99: *The Old (or First) Statistical Account of Scotland* by Sir John Sinclair (1754–1835)

Sinclair was a Scottish politician and the first person to use the word 'statistics'. His pioneering twenty-one-volume work ranks as one of the finest European contemporary records of life during the agricultural and industrial revolutions. He was educated at Edinburgh High School and studied law at Edinburgh University. He lived at No. 133 George Street, New Town, and is buried in the Royal Chapel at Holyrood Abbey.

1779: *A History of Edinburgh* by Hugo Arnot (1749–86)

Arnot was an advocate who lived in West Register Street, just off Princes Street. He is buried in South Leith Parish Churchyard.

Fun Fact: Arnot was eccentric, irritable and foul-mouthed. When neighbours complained about him ringing a loud hand-bell to summon his servant, he used a pistol instead.

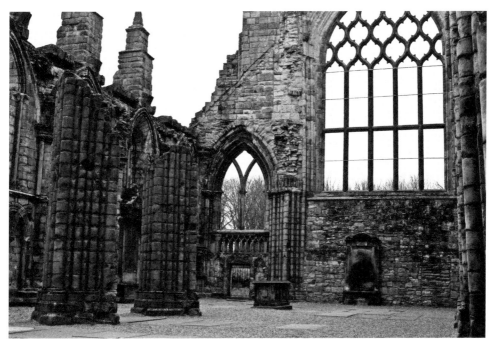

Royal Chapel, Holyrood Abbey.

7. Early Nineteenth Century: The Practical Era

The late eighteenth century had been a time of exceptional ideas and incredible people, burning brightly. Literary works in the nineteenth century were just as influential, but markedly less radical. Scotland (and especially Edinburgh) had established itself as the engine of the British Empire and the city was keen to consolidate this position – concentrating on the acquisition of knowledge rather than soul searching. With the shiny new New Town to live in and a reputation to keep up, the citizens considered self-improvement and empirical inquiry to be fundamental to good living – an era of building on what had come before, rather than formulating revolutionary new theories. As such, the writing of the time cemented the city's status as a nexus of considered and thoughtful ideas.

It also became a leading publishing hub, led by giants such as the Chambers Brothers (see William Chambers), William Constable (see William Constable), Adam and Charles Black (see A & C Black), Blackwoods (see Blackwoods) and John Murray (who published Jane Austen, Sir Arthur Conan Doyle, Lord Byron, Charles Lyell, Johann Wolfgang von Goethe, Herman Melville and Charles Darwin).

Finally, women began to make an appearance in literature, which is a whole can of worms I don't have space to go into. Let's just say it's about time, though they faced an uphill struggle.

There were a few giants still waiting in the wings and the supernatural was about to emerge yet again, as writers saw the potential for horror in the inexorable progress of science.

1802–1929: *The Edinburgh Review* Founded

Though it began in 1755, *The Edinburgh Review*'s third incarnation was the one that really took off. It was founded by the writers Francis Jeffrey (1773–1850), Sydney Smith (1771–1845) and Henry Brougham (1778–1868), with Jeffrey as its original and long-time editor. It was published by Archibald Constable (1774–1827), regarded as the first 'modern' publisher, who took the previously unheard-of step of paying writers fees, which actually matched their talents – saving many a struggling author from starvation. The *Review* was an immensely influential quarterly of literary and political criticism and its contributors included Adam Smith, Sir Walter Scott, Herbert Spencer, Francis Horner, John Stuart Mill and Bertrand Russell.

Fun Fact: Henry Brougham was a complete pain in the neck, but instrumental in abolishing the British slave trade. He also invented the Brougham carriage and popularised the fishing village of Cannes as a tourist destination. He has a statue there, though it's a bit off the beaten track for visitors to Edinburgh.

Landmarks: Jeffrey was schooled in Bailie Fyfe's Close, lived at No. 22–24 Moray Place and is buried in Dean Cemetery. Jeffrey Street is named after him. Smith lived at No. 46 George Street, while Brougham was born in the Cowgate and educated at the Royal High School. The most famous editions of the *Review* were published in Trunks Close. Constable is buried in Old Calton Cemetery.

1802: *Illustrations of the Huttonian Theory of the Earth* by John Playfair (1748–1819)

Playfair popularised the work of James Hutton but was also, at various times, a millwright, engineer, draftsman, accountant, inventor, silversmith, merchant, investment broker, economist, statistician, pamphleteer, translator, publicist, land speculator, banker, editor and journalist. He was also the founder of graphical methods of statistics and invented the pie chart. He succeeded Dugald Stewart to the University of Edinburgh's Chair of Moral Philosophy and was tutor for Adam Ferguson. And he's not even the most famous one in his family. That's his nephew William Playfair, one of the greatest architects of the nineteenth century.

Fun Fact: Playfair served as a British secret agent during the French Revolutionary Wars, took part in the storming of the Bastille and organised a counterfeiting operation to try and collapse the French currency.

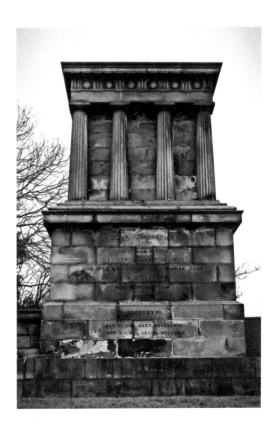

Playfair Memorial, Calton Hill.

Albany Street.

Landmarks: Playfair lived at No. 2 Albany Street and is buried in an unmarked grave in Old Calton Burial Ground on Waterloo Place. He has a monument by William Playfair on Calton Hill.

1804: *Of the Experimental Inquiry into the Nature and Properties of Heat* by John Leslie (1766–1832)

Leslie was a mathematician and physicist who gave the first modern account of capillary action, co-invented the differential thermometer and was the first man to artificially produce ice, vital to preserving fresh food. If you don't think that's important, try living without a fridge and only buying produce that hasn't been shipped. Oh, wait. You can't.

Landmarks: Leslie held the Chair of Mathematics (despite violent opposition at his being an atheist), then Natural Philosophy at Edinburgh University. He lived at No. 62 Queen Street.

1807: A & C Black Founded

Begun by Adam Black (1784–1874), A & C Black published Walter Scott, later editions of the *Encyclopaedia Britannica, Who's Who, The Whitaker's Almanack, Black's Travel Guides, Black's Medical Dictionary* and *The Writers' & Artists' Yearbook.* It also discovered P. G. Wodehouse. It was purchased by Bloomsbury in 2002.

Landmarks: A & C Black began in a bookshop at No. 27 North Bridge. Black was educated at the Royal High School, lived at No. 30 Broughton Place and has a statue in East Princes Street Gardens. He is buried in Warriston Cemetery.

Warriston Cemetery.

1817: *Rob Roy* by Sir Walter Scott (1771–1832)

Scott is another goliath of literature and once the world's most popular writer. He invented the historical novel, popularised the Highlands as a tourist destination and discovered the Scottish Crown Jewels, after they had been missing for over a century.

But his greatest contribution to the world stage is one of the least known. He organised the first official visit by a British monarch to Scotland in almost two centuries – the undeserving George IV (1762–1830). As part of the festivities, Scott invited Highland clans to the city, and they came – because they owed him one for depicting the Highlands so nobly. Northerners paraded through the city in made-up tartan finery, designed by Edinburgh tailors to Scott's specifications. Yup. The man pretty much invented Highland dress as well.

Astonishingly, the Lowlanders and Highlanders got on well, ending centuries of animosity. A country that had lost its monarch, its independence and its identity finally saw itself as a complete nation. Scott's 'tartan pageant' turned this totally manufactured charade of a united Scotland into a 'reality' the rest of the world now perceives as truth.

If that wasn't enough, Mark Twain insisted Scott's writing was so influential in the Southern states, he caused the American Civil War:

> He did measureless harm; more real and lasting harm, perhaps, than any other individual that ever wrote… Sir Walter had so large a hand in making Southern character, as it existed before the war, that he is in great measure responsible for the war.

Now *that's* some serious impact for an author!

Landmarks: Scott was born in what is now Guthrie Street and lived at No. 25 George Square, No. 50 George Street and No. 39 North Castle Street. He is commemorated in the Writers' Museum and Makar's Court, Waverley Station is named after his celebrated novel of the same name and the Walter Scott Monument on Princes Street is the world's tallest monument to a writer.

 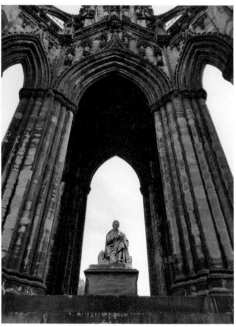

Above left: Walter Scott Monument, Princes Street.

Above right: Detail of Scott Monument.

1817: *Blackwood's Magazine* Founded

This was begun by William Blackwood (1776–1834) and originally edited by John Wilson (1785–1854), who wrote under the name Christopher North. *Blackwood's* helped popularise the works of British romanticists like Percy Shelley and Samuel Taylor Coleridge, as well as launching the career of the then unknown George Eliot. It featured

Anne Street, Stockbridge.

writers as diverse as Sir Walter Scott, Anthony Trollope, Joseph Conrad, James Hogg, Thomas De Quincey, Henry James, Oscar Wilde, Elizabeth Barrett Browning, John Buchan, Walter de la Mare, J. B. Priestley and Hugh MacDiarmid. It also printed a lot of horror fiction (there's a surprise) and is regarded as an important influence on writers such as Charles Dickens, the Brontë sisters, and Edgar Allan Poe. It ceased publication in 1980.

Fun Fact: *Blackwood's* rejected a story by eighteen-year-old Arthur Conan Doyle featuring prototype versions of Sherlock Holmes and Dr Watson, because Doyle didn't enclose a stamped addressed envelope.

Landmarks: *Blackwood's* was based at No. 45 George Street. North lived in Anne Street and No. 6 Gloucester Place and is buried in Dean Cemetery. There is a statue commemorating him in Princes Street Gardens.

1818: *Married Love* by Marie Stopes (1880–1958)

Palaeobotanist Marie Charlotte Carmichael Stopes certainly touched a few nerves. This best-seller was as controversial as it was important, bringing the subject of birth control into public discourse and insisting husbands and wives were equal partners. Imagine that.

It was branded obscene in the USA and Stopes' pioneering work on sex education (along with her founding of Britain's first birth control clinic) led to her being condemned by the Catholic Church and likened to Hitler. Stopes had her flaws (she was a supporter of eugenics), but her defiance of rampant misogyny and the freedom she inspired women to grasp, marks her out as one of the most influential women of the twentieth century. There are now Marie Stopes clinics all over the world.

Landmarks: Stopes was born at No. 3 Abercrombie Place.

1818: *Frankenstein* by Mary Shelley (1797–1851)
1819: *The Vampyre* by John William Polidori (1795–1821)

Just when you thought Edinburgh might have shed its sinister reputation, it becomes the catalyst for two of the world's most famous characters in horror.

Edinburgh University's Medical School led the world in anatomy but needed bodies for the students to practise on, which led to a thriving trade in 'bodysnatching'. At the same time, Edinburgh and Glasgow universities were experimenting with 'Medical Electricity', attempting to bring bodies back from the dead by passing electrical currents through them. A student at Edinburgh University, John William Polidori was familiar with these – and his medical degree landed him a job as the personal physician to Lord Byron (1788–1824).

Eventually, Polidori found himself at a party on the shore of Lake Geneva, with Mary Wollstonecraft Shelley, her husband Percy Shelley (1792–1822) and Byron. As a bet they all wrote horror stories to scare themselves and, ironically, arch egoists Shelley and Byron's efforts are forgotten. Mary Shelley, on the other hand,

Frankenstein's Pub, George IV Bridge.

was obviously inspired by Polidori's experiences (and may even have attended 'Galvanic' lectures herself). She came up with *Frankenstein*, about a doctor who revives stolen bodies of criminals by passing electricity through them. A year later, Polidori penned *The Vampyre*, featuring a suave, dentally challenged nobleman. He launched an entire genre in the process and influenced the book that took it to stratospheric levels – *Dracula* by Bram Stoker.

And there were even more monsters hidden in Edinburgh's literary closet, waiting to be unleashed.

Fun Fact: Frankenstein's pub on George IV Bridge has an inscription above its doorway, stating 'Founded 1818'. Either the pub's creators were astonishingly quick off the mark, or it's a bit misleading.

Landmarks: Mary and Percy Shelley stayed at No. 36 Fredrick Street for short time, while Polidori studied at Edinburgh University.

1817: *The Scotsman* Newspaper Founded by John Ritchie Findlay (1824–98)

Findlay was a renowned philanthropist who paid for the Scottish National Portrait Gallery to be built and was instrumental in achieving the admission of women to the University of Edinburgh Medical School. He was a champion of ideal workers' housing, including the picturesque Well Court in Dean Village. A modest man, he avoided political office and refused the offer of a baronetcy.

Landmarks: Findlay lived at No. 3 Rothesay Terrace and has a monument in Dean Cemetery, where he is buried. *The Scotsman* was originally based at No. 257 High Street on the Royal Mile, moved to the North Bridge (presently the Scotsman Hotel) and is now next to the Scottish Parliament at Holyrood.

Well Court,
Dean Village.

1821: *Confessions of an English Opium-Eater* by Thomas De Quincey (1785–1859)

This is one of the first journalistic exposés of a social evil, told from an insider's point of view. It doesn't shy away from the pleasures of the drug either. This masterpiece was the *Trainspotting* of its day and influenced Edgar Allan Poe, Fitz Hugh Ludlow, Charles Baudelaire, Nikolai Gogol, Jorge Luis Borges and the noted horror filmmaker Dario Argento.

Landmarks: De Quincey lived at No. 9 Great King Street and is buried in St Cuthbert's Churchyard.

Thomas De Quincey's grave, St Cuthbert's.

1824: *The Private Memoirs and Confessions of a Justified Sinner* by James Hogg (1770–1835)

Ignored on its release, *Confessions* is now regarded as a hugely influential and original work. It was the first novel to tackle either schizophrenia or demonic possession, depending on how you interpret it – topics which would go on to become staples of crime and horror. In any case, the book was years ahead of its time and would inspire *another* great horror novel, which we'll come to soon.

Fun Fact: The book was originally published anonymously (a fine Edinburgh tradition) because Hogg was afraid to put his name to it.

Landmarks: Hogg lived in Deanhaugh Street and parts of his book are set in Greyfriars Kirk and Kirkyard. He also periodically lodged in Candlemaker Row, just outside the graveyard.

1831: *The Man-Wolf* by Leitch Ritchie (1800–65)

Yet another horror icon appears. The werewolf legend is as old as the hills, but this is one of the very first literary forays into the genre.

Landmarks: Ritchie lived at No. 17 St Bernard's Crescent.

St Bernard's Crescent, Stockbridge.

1842: *Vestiarium Scoticum* by Charles Edward Stuart and John Sobieski Stuart

The Sobieski Stuarts claimed to be grandsons of Bonnie Prince Charlie, but were John and Charles Allen, born in Wales to the son of a shady naval officer. They insisted *Vestiarium Scoticum* was a copy of a fifteenth-century manuscript and further writings contained details of ancient clan dress (despite the fact that there wasn't really any such thing). They were eventually unmasked, but not before adding to the fake image of Highlanders as looking like tartan Beau Brummels.

Landmarks: The brothers lived at Hill Street in the New Town.

1843: *A Christmas Carol* by Charles Dickens (1812–70)

Back to the supernatural again. In 1841, Dickens visited Edinburgh and wandered into Canongate Kirkyard, where he found a headstone bearing the disturbing inscription 'Ebenezer Scroggie. Mean man.'

Dickens was shocked. What kind of guy was so nasty even his headstone slagged him off? He then wrote *A Christmas Carol*, the story of Ebenezer Scrooge. But he had read the inscription incorrectly – which actually said 'Ebenezer Scroggie. Meal Man.' The poor sod was an Edinburgh corn dealer.

A Christmas Carol has three of the most vivid paranormal beings ever to grace the pages of English literature – the ghosts of past, present and future. Dickens was the most famous writer in the world and the massive success of this 'Ghostly Little

Approximate location of Ebenezer Scroggie's grave, Canongate.

Book' (which doesn't mention religion or Jesus) changed the way we thought of the festive season forever. Christmas began to morph from a low-key religious ritual into the gigantic, secular, turkey-gobbling, present-giving orgy we enjoy today. Bah, humbug!

Landmarks: Ebenezer Scroggie's headstone in Canongate is now gone. Dickens himself read the book at the Assembly Rooms in George Street, to rapturous applause.

1844: *Vestiges of the Natural History of Creation* by Robert Chambers (1802–71)

Chambers was a publisher, editor and geologist who seemed destined for a life of modest fame. Then came *Vestiges of the Natural History of Creation* and Chambers did his damnedest to make sure nobody would ever find out he was the author. He had his wife transcribe it, to disguise his handwriting, and insisted it be published anonymously. Why? Because *Vestiges* claimed life was a product of evolution. Chambers called his theory 'Transmutation' and argued life could be created by spontaneous generation. Modern scientists now agree that, millions of years ago, inanimate matter may have been sparked into life by chemical reactions in some primordial soup.

Assembly Rooms, George Street.

The book was so controversial, it caused national outrage and was loudly condemned. So loudly it was read by Charles Darwin.

Other Works of Note

1802: *Self-Control* by Mary Brunton (1778–1818)

Brunton's most famous work, about the travails of a self-sufficient female, was published anonymously – as women in the early nineteenth century were still castigated for stepping outside the role of dutiful wife and home-maker. She lived at No. 3 St John Street and is buried in Canongate Kirkyard.

1818: *Marriage* by Susan Ferrier (1782–1854)

Moralistic but humorous and filled with insightful observations, *Marriage* was also written anonymously. Though her books were immensely popular in their day, Ferrier has vanished into obscurity. She lived at East Morningside House in Clinton Road and is buried in St Cuthbert's Churchyard.

1821: *Annals of the Parish* by John Galt (1779–1839)

John Galt is considered the original political novelist of the English language. He was also the first superintendent of the Canada Company – the most important single attempt at settlement in Canadian history. He wrote for *Blackwood's Magazine* and lived in Musselburgh, just outside Edinburgh.

1827: *The Youth and Manhood of Cyril Thornton* by Thomas Hamilton (1789–1842)

This satire is considered one of the great novels about military life. Hamilton fought in the Peninsular Wars and lived at No. 12 Great King Street.

1837: *The French Revolution: A History* by Thomas Carlyle (1795–1881)

Carlyle was a philosopher, translator and mathematician. Charles Dickens claimed to have read his book 500 times and used it as the inspiration for *A Tale of Two Cities*. Carlyle lived at No. 21 Comely Bank.

1837–83: *Sir Walter Scott* by J. G. Lockhart (1794–1854)

John Gibson Lockhart was a novelist and editor of *Blackwood's Magazine*, but his best-known work is a definitive seven-volume tome on his father-in-law, Sir Walter Scott. It is regarded as a rival to Boswell's *Life of Samuel Johnson* as the best biography ever written. He lived at No. 37 Bellfield Street and No. 37 Melville Street.

1839: *Holiday House: A Book for the Young* by Catherine Sinclair (1800–64)

Holiday House was a massive hit with children, partly because it shunned stuffy Victorian moralising. Catherine Sinclair has a monument in North Charlotte Street and is buried in St John's Churchyard on Princes Street.

Catherine Sinclair monument,
North Charlotte Street.

1853: *Homoeopathy, Its Tenets and Tendencies* by James Young Simpson
(1811–70)

Simpson's book rubbished the idea of homoeopathy, which makes me really like him. The first physician to demonstrate the properties of chloroform, he introduced the use of anaesthesia to assist childbirth – which went down like a lead balloon until Queen Victoria used it. After that, it was all the rage. He also helped popularise midwives. He lived at No. 52 Queen Street.

James Young Simpson's grave,
Warriston Cemetery.

8. Late Nineteenth Century: Literature Takes Flight

By the late nineteenth century, Scotland's effect on the British Empire had far surpassed its size. Scots worthies were still prominent in the military, science, exploration, politics and engineering, while Edinburgh was recognised as the epicentre of this practical and erudite nation. Literature, at last, was branching out, with an eclectic mixture of realistic, practical, fantastic, horror and children's novels. Yet, a loss of simpler times was being felt – whether real or not – so a gentle and quaint depiction of southern Scotland was beginning to take root in Edinburgh books. Or perhaps the writers were just jealous of how popular the Highlanders had become. And two more leviathans of writing appear, as well as a book that changed the planet.

1857: *The Coral Island* by R. M. Ballantyne (1825–94)

Robert Michael Ballantyne wrote children's novels about heroes who were models of self-reliance and moral uprightness, two characteristics prized by the Victorians. Making one mistake on *The Coral Island* (the incorrect thickness of coconut shells), he subsequently attempted to gain intimate first-hand knowledge of his subject matter, making him a pioneer of authentic novelistic research. His work influenced Robert Louis Stevenson, who admired this book so much, he copied some of the themes for *Treasure Island*.

Fun Fact: Ballantyne stayed at Bells Rock Lighthouse to research *The Lighthouse*, lived with tin miners for *Deep Down* and joined the London Fire Brigade for *Fighting the Flames*.

Landmarks: He was born at No. 25 Ann Street in the New Town and lived at No. 20 Fettes Row.

1859: *Chambers's Encyclopaedia* First Printed

With his brother Robert, William Chambers (1800–83) pioneered the use of industrial publishing technologies to make books cheaply available. W&R Chambers also published the *Chambers's Edinburgh Journal*, *Chambers's Encyclopaedia* and *Chambers's English Dictionary*. By the end of the 1800s, it was one of the largest English-language publishers in the world and is still in existence.

Landmarks: Chambers lived at No. 13 Chester Street. Chambers Street is named after him and he has his statue at its centre, as well as an aisle in St Giles' Cathedral.

1859: *On the Origin of Species* by Charles Darwin (1809–82)

Darwin's work of scientific literature is one of the most influential books ever written, his theory of evolution completely changing the way mankind thought of itself.

Though English, Darwin attended medical school in Edinburgh where he joined the Plinian Society, a group of radical students challenging orthodox religious concepts of science. He read his grandfather Erasmus' journals (who wrote about Lord Monboddo's theories) and the works of James Hutton and Robert Chambers. The reception those writers got may well have put him off, for he sat on his own theories for decades – a wise move in hindsight. Instead, he waited until he was a respected authority with a huge body of well-researched evidence, before releasing his bombshell.

This time, ideas that had been percolating in Edinburgh for almost a century simply couldn't be ignored or brushed aside. And some recognised the contribution made by Darwin's predecessors. The writer Charles Neaves (1800–76) summed it up in these lines: 'Though Darwin now proclaims the law. And spreads it far abroad, O! The man that first the secret saw. Was honest old Monboddo.'

1865: *Report on the Sanitary Conditions of the City of Edinburgh* by Sir Henry Duncan Littlejohn (1826–1914)

Littlejohn typified the can-do attitude of nineteenth-century Edinburgh. At various times he was the city's police surgeon, Medical Officer for Health, Head of the University Chair of Forensic Medicine, co-founder of Edinburgh Sick Kid's hospital, lecturer in medical jurisprudence at the Royal College of Surgeons and Commissioner of the Board of Supervision, which oversaw the city's sanitary conditions. I presume he slept at some point. His devastating report on the Royal Mile saw most of its buildings demolished and rebuilt. Yes, it's not as old as you think.

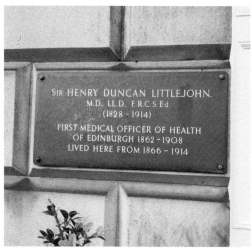

Above: Henry Littlejohn's House, No. 24 Royal Circus.

Left: Henry Littlejohn's grave, Dean Cemetery.

Fun Fact: Along with Edinburgh lecturer Joseph Bell (1837–1911), Littlejohn was one of the inspirations for Sherlock Holmes.

Landmarks: Littlejohn lived at No. 24 Royal Circus and has a commemorative plaque outside.

1886: *The Strange Case of Dr Jekyll and Mr Hyde* by Robert Louis Stevenson (1850–94)

One of the world's most famous and widely translated authors, Stevenson wrote classics like *Treasure Island*, *Kidnapped* and the wonderful *A Child's Garden of Verses*. But, to me, his masterpiece is *Dr Jekyll and Mr Hyde*. Though set in London, it has many Edinburgh influences, including James Hogg's *Confessions of a Justified Sinner* and the life of Deacon Brodie (1741–88), town councillor by day and burglar by night. But the main catalyst may well be Edinburgh itself, often referred to as the 'Jekyll and Hyde City'.

This massive best-seller was read all over the world and it isn't hard to see some of the legends it popularised – modern werewolf stories for one thing, where a decent man changes into an uncontrollable beast. Along with *A Christmas Carol*, *Frankenstein* and *Dracula*, it has become one of the most filmed novels of all time.

It also influenced an obscure Austrian scientist called Sigmund Freud, who stopped conducting experiments on eel's testicles – or whatever he was up to – and put forward the theory that each of us is made up of a moral superego and a savage id. This kick-started the science of psychology, a discipline that its practitioners have been struggling to get right ever since – usually for £500 an hour.

But a very different (and equally world-changing) movement sprang up after the publication of *Jekyll and Hyde*, inspired by a combination of Darwin's 'Survival of the Fittest' and the Victorian notion of who the fittest actually were. Ignoring the fact that Stevenson was being subtly satirical, scientists and doctors from the upper classes decided they were morally and intellectually superior to everyone else, so it was their duty to fix this gap by any means necessary. They called the movement 'Social Darwinism' and it reached its apex with a force that changed the world in the most horrible way – by designating other races and classes as 'subhuman'.

The Nazis.

Fun Fact: A pond in Queen Street Gardens, opposite Stevenson's window, became the inspiration for *Treasure Island*.

Landmarks: Stevenson was born at No. 8 Howard Place, moved to No. 9 Inverleith Terrace, then No. 17 Heriot Row. Colinton Parish Church, where his grandfather was minister, still has a swing (with its original fittings) that Stevenson played on, inspiring his poem *The Swing*. The Hawes Inn in South Queensferry was a favourite haunt, and he began *Kidnapped* while staying there, mentioning it as the site where David meets Captain Hose. (Sir Walter Scott also used it as a setting in his novel *The Antiquary*.) He has a monument on Corstorphine Hill, a statue celebrating *Kidnapped* on

Corstorphine Road, a large memorial plaque in St Giles' and is one of the three authors celebrated in the Writers' Museum.

Deacon Brodie's birthplace is at Brodie's Close on the Royal Mile, with Deacon Brodie's Tavern across the road.

Left: Deacon Brodie's birthplace, Royal Mile.

Below: R. L. Stevenson's swing, Colinton.

The Hawes Inn,
South Queensferry.

R. L. Stevenson's House.

Stevenson plaque,
St Giles' Cathedral.

1887: *A Study in Scarlet* by Arthur Conan Doyle (1859–1930)

With *A Study in Scarlet*, Arthur Conan Doyle introduced one of the most enduring characters in literature – Sherlock Holmes. Though the books became milestones of crime fiction, they were hated by Doyle, who wanted to write 'serious' novels, but never emerged from his creation's vast shadow. To this day, Holmes is the most filmed character in movie history.

Conan Doyle also influenced the world in the strangest way. He was the most famous champion of 'Spiritualism' – a belief that the dead could be contacted. Only in Edinburgh, eh? Even when many spiritualists were proved to be phonies, Doyle remained a believer. It's odd that the man who invented a doyen of logic should be taken in by such a dubious movement but, partly due to his staunch convictions, spiritualism is going strong today. Its central concept, the existence of ghosts, is the basis for thousands of horror books and movies.

To his credit, however, Doyle was a staunch supporter of compulsory vaccination and wrote several articles denouncing the views of anti-vaccinators. Ahead of his time, or what?

Fun Fact: One of Conan Doyle's early short stories, *J. Habakuk Jephson's Statement*, helped popularise the mystery of the *Mary Celeste*.

Landmarks: Conan Doyle was born at No. 11 Picardy Place, now the site of a traffic roundabout. There is a statue of Sherlock Holmes overlooking it and the Conan Doyle bar is next door. He lived at 3 Sciennes Place, 2 Argyle Park Terrace and 32 George Square. No 25 Palmerstone Place is now the Arthur Conan Doyle Centre and his adventure epic *The Lost World* is inspired by Salisbury Crags.

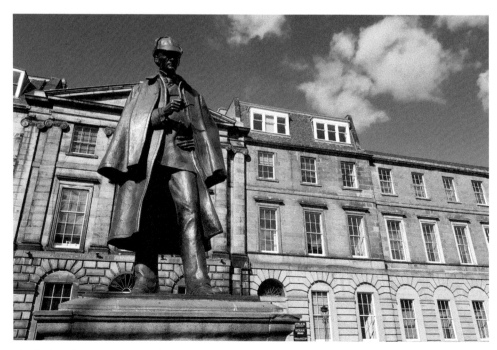

Sherlock Holmes statue, Picardy Place. (JH)

Right: Conan Doyle Centre, Palmerston Place. (JH)

Below: Salisbury Crags.

1873: *A Treatise on Electricity and Magnetism* by James Clerk Maxwell (1831–79)

By the late nineteenth century, Edinburgh's days of truly innovative thinkers had given way to more industrious but, frankly, less astonishing ones. Then one of the greatest minds in history burst onto the scene.

James Clerk Maxwell is the most influential scientist nobody has ever heard of. It is no exaggeration to say that modern physics owes him its very existence. This 'Father of Modern Physics' came up with one of the most significant discoveries of all time – the theory of electromagnetism. He proved that light is an electromagnetic wave and so linked electricity, magnetism and optics, pointing the way to the existence of the spectrum of electromagnetic radiation. His kinetic theory of gases explained the origin of temperature. His work laid the foundation for quantum theory. He was the first person to produce a colour photograph. He used mathematics to explain Saturn's rings, over a century before the Voyager probe confirmed his findings. And he wrote poetry.

What a guy.

Fun Fact: When Albert Einstein was asked if he had stood on the shoulders of Newton, he replied, 'No, I stand on Maxwell's shoulders.' He also claimed his Special Theory of Relativity owed its origins to Maxwell's equations.

Landmarks: Maxwell has a statue in George Street and lived at No. 31 Heriot Row. He was born in No. 14 India Street, now the site of the James Clerk Maxwell Foundation.

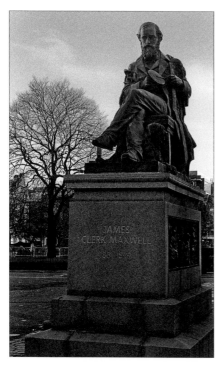

James Clerk Maxwell statue, George Street.

1880: The Tay Bridge Disaster by William McGonagall (1825–1902)

William Topaz McGonagall was a weaver and, quite possibly, the worst poet who ever lived. Though he didn't begin writing until he was fifty-four and had little education, he was convinced of his own genius, despite everyone else recognising he was total rubbish. As such, he is a worldwide inspiration for writers with a total lack of talent but a can-do attitude. Ridiculed though he may be, he has the last laugh. Everything this much-loved misfit wrote is still in print today. Read his description of Edinburgh and marvel:

> Beautiful city of Edinburgh, most wonderful to be seen;
> with your ancient palace of Holyrood and Queen's Park Green;
> and your big, magnificent, elegant New College;
> where people from all nations can be taught knowledge.

Landmarks: McGonagall was reputedly born in the Cowgate and has a small plaque in Greyfriars Graveyard. He died in poverty at South College Street.

McGonagall plaque, Greyfriars.

Royal Lyceum, Grindlay Street.

1883: The Royal Lyceum Theatre Built

The Royal Lyceum on Grindlay Street is primarily known for drama, though it also hosts operas. Apart from a glass extension on the front, it remains remarkably unaltered. The theatre was the first in Britain to be fitted with an iron safety curtain, and to use electricity for house lighting.

1890: *The Picture of Dorian Gray* by Oscar Wilde (1854–1934)

Another famous horror. Another Edinburgh connection. I'll admit this one is tenuous but it's a good story, so I'm keeping it. Wilde was obsessed with a handsome young poet called John Gray, who wrote him letters signed 'Dorian'. When Wilde shifted his attention to Lord Alfred Douglas, a near suicidal Gray became a priest and moved to Edinburgh.

Landmarks: Gray served as a curate at St Patrick's Church in the Cowgate and is buried in St Vernon's Cemetery.

1893: *The Stickit Minister* by S. R. Crockett (1860–1914)

Samuel Rutherford Crockett was one of the most successful proponents of the 'Kailyard School', depicting rural Scottish life in a natural and unsophisticated way. Though immensely popular, the school eventually descended into mawkish sentimentality, provoking a hostile reaction among contemporary Scottish realists and later writers. But it colours the world's view of the Scottish countryside as a simple, happy Brigadoon-like place to this day.

Fun Fact: Crockett is virtually unknown now, but was greatly admired by Robert Louis Stevenson, who wrote a poem about him.

Landmarks: Crockett attended Edinburgh University and was minister at Penicuik South Church on Peebles Road.

1897: *Dracula* by Bram Stoker (1847–1912)

Abraham Stoker launched the modern vampire craze with his Gothic novel. It's popularly thought the character was based on Vlad III Dracula of Romania and, though Stoker researched European folklore, his own notes don't really mention poor old Vlad. His toothy, aristocratic count bears a much greater resemblance to John Polidori's *Vampyre*, which means Polidori's time in Edinburgh was the catalyst for both *Dracula* and *Frankenstein*.

Other Works of Note

1856: *Memorials of His Time by* Henry Thomas Cockburn (1779–1854)

This is a wonderfully nostalgic look at the golden age of Edinburgh, by a man who had witnessed many great events in the city's history. Cockburn lived at No. 14 Charlotte Square in the New Town and is buried in Dean Cemetery.

1856: *The Use and Abuse of Tobacco* by John Lizars (1792–1860)

Lizars was Professor of Surgery at the Royal College of Surgeons and had Charles Darwin as a pupil. His book warned of the dangers of smoking, a position that took over a century to be recognised. Ironically, he died of an overdose of laudanum. Lizars lived at No. 38 York Place in the New Town, then No. 15 South Charlotte Street, off Charlotte Square. He is buried in St Cuthbert's Churchyard.

Dean Cemetery, burial place of several notable writers.

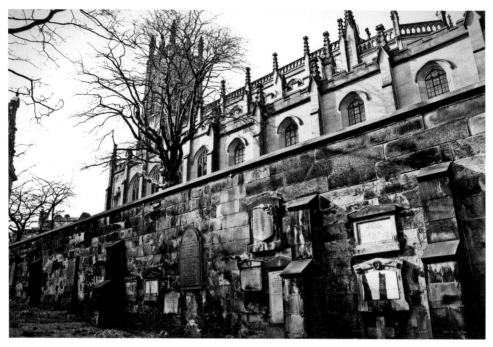

Church of St John, Princes Street.

1858: *Reminiscences of Scottish Life and Character* by Very Revd Edward
Bannerman Ramsay (1793–1872)

Author of an excellent collection of anecdotes about Scotland, Ramsay was born in George
Street, educated at the High School and lived at No. 36 Melville Street, No. 7 Darnaway
Street and No. 23 Ainslie Place. He was minister of St John's Episcopal Church and is buried
in the Covenanter's Prison. He has a memorial in the grounds of the Church of St John's.

1859: *Rab and His Friends* Dr John Brown (1810–82)

Brown was a friend of Thackeray and Mark Twain (whose sick wife he cured) and wrote
acclaimed papers on art, medical history and biography. But he is better known for
Rab and His Friends, a melancholy tale about a large faithful dog. He was educated at

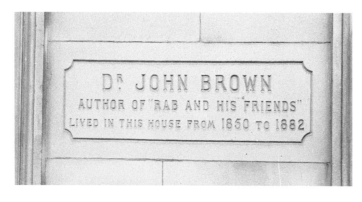

John Brown plaque,
Rutland Street.

New Calton Cemetery.

Edinburgh High School and the University of Edinburgh, died at No. 23 Rutland Street and is buried in New Calton Cemetery.

Fun Fact: *Rab and His Friends* was consigned to obscurity when *Greyfriars Bobby* was published (see Eleanor Atkinson). There was only room for one clingy pooch in Edinburgh and Bobby came out as top dog. Sorry, couldn't resist that.

1883: *Aldersyde* by Annie Swan (1859–1943)
Another prolific writer whose sentimental novels about feminine virtue were huge in their day but now forgotten. She lived at the top of Easter Road.

1892: *Atlas of Clinical Medicine* by Sir Byrom Bramwell (1847–1931)
Instrumental in promoting the education of women as physicians, Bramwell was an eminent brain surgeon. He lived at No. 10 Heriot Row and is buried in Dean Cemetery.

1894: *Beside the Bonnie Brier Bush* by Ian Maclaren (1850–1907)
The Revd Dr John Watson (Ian Maclaren) was another wildly successful 'Kailyard' author. He studied at Edinburgh University and New College and became assistant minister of Barclay Church.

1899: *The Story of Little Black Sambo* by Helen Bannerman (1862–1946)
A gigantic best-seller, it is understandably controversial to the modern reader. If nothing else, it illustrates how something considered harmless in colonial times is now highly offensive. The stereotypical illustrations (and calling the child's parents Black Jumbo and Black Mumbo) didn't help.

9. Early Twentieth Century: Settling into Our Skin

By the twentieth century, the Edinburgh Enlightenment was effectively over. The city was still thriving, but its groundbreaking past had given way to a respectable, workmanlike present. Edinburgh literature, however, was growing in stature and confidence. It saw the revival of a 'warts and all' portrayal of Scottish life and a poetry renaissance, using the common vernacular. These rescued or reinvented genuine ancient traditions, rather than perpetuating the bogus romanticism espoused by the likes of Walter Scott, James Macpherson and the Kailyard School. The city was beginning to appreciate the importance of its own literary heritage and was no longer reluctant to branch out, defy conventional tropes or explore an authentic Scottish voice. Female writers also began to make inroads into a hitherto male-dominated scene. Theatre was finally taking off.

In short, things were getting pretty arty.

1906: The King's Theatre Built
Originally a variety touring house, this A-listed building on Leven Street is still going strong and is well known for its annual pantomime. Oh, no it isn't! Oh, yes it is!

King's Theatre, Leven Street.

1907: The Writers' Museum Founded

The Writers' Museum celebrates three literary biggies, inside a building originally constructed in 1622. To begin with, it only contained artefacts relating to Robert Burns and Walter Scott but Robert Louis Stevenson's possessions were added in 1962.

Landmarks: The museum is in Lady Stair's Close. Next to it is Makars' Court, where plaques set in the pavement celebrates Scottish literature. (Makar is a Scots language term for writer.) The Scottish Parliament, at the bottom of the Mile, has similar inscriptions on its walls.

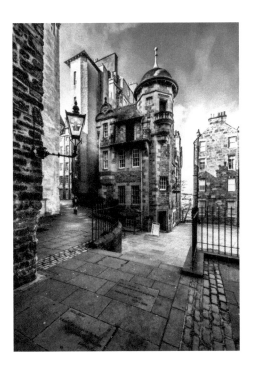

Writers' Museum, Royal Mile.

Scottish parliament.

Kenneth Grahame's
birthplace, Castle Street.

1908: *The Wind in the Willows* by Kenneth Grahame (1859–1932)

Kenneth Grahame produced one of the best-loved kid's books of all time. He based its most famous character, bumbling 'Mr Toad', on his son, Alastair, who later committed suicide. I'm sure there's a lesson to be learned there.

Fun Fact: Despite the book's enormous success, Grahame never attempted a sequel.

Landmarks: Graham was born and lived at No. 30 Castle Street in the New Town.

1910: Founding of Milnes Bar

Milnes Bar began as a Georgian house and went through many uses before becoming Lomond and Mills Wine Merchant in 1910, then Milnes Pub in the 1950s. Patrons included Stevie Smith, Dylan Thomas and W. H. Auden. It is also famous as the

Interior of Milnes Bar,
Hanover Street.

haunt of the Scottish Renaissance poets Hugh MacDiarmid, Sydney Goodsir Smith, Sorley MacLean and Norman MacCaig. These very different men engaged in lively political and poetic debate in a room hailed as the 'Little Kremlin', which is still part of the pub.

Landmarks: The bar is located at No. 35 Hanover Street, New Town. Unfortunately, the inside has been renovated and bears little resemblance to its heyday.

1911: *Peter Pan* by J. M. Barrie (1860–1937)

James Matthew Barrie is the creator of one of the most iconic characters in literature. Barrie is often described as the most famous proponent of the Kailyard School, but his talents went way beyond sentimental slush. Innocent on the surface, *Peter Pan* contains some rather sinister overtones and Peter himself has a Jekyll and Hyde vibe going on – rather like the man himself, who has been accused of an unhealthy interest in the children of the family who inspired it.

Since both of us come from Kirriemuir, I feel obliged to defend him. Barrie was a controlling, mixed-up man but also completely unsexual and impotent. He simply craved the love denied him by his mother, and sought it in the innocence of others' childhoods.

Fun Fact: Barrie seems to have invented the name 'Wendy', which doesn't appear anywhere before *Peter Pan*. Feel free to prove me wrong.

Landmarks: Barrie gained an MA from Edinburgh University Old College and lived at No. 3 Great King Street, No. 20 Shandwick Place and No. 14 Cumberland Street.

J. M. Barrie's House, Great King Street.

Bobby's statue, outside Greyfriars Graveyard.

1912: *Greyfriars Bobby* by Eleanor Atkinson (1863–1942)

Eleanor Stackhouse Atkinson was an American, who never set foot in Edinburgh. It didn't stop her telling the story of a real dog who sat on his master's grave in Greyfriars Graveyard for fourteen years. Riddled with inaccuracies, it still became a children's classic and achieved even more fame when Walt Disney turned the story into a much-loved movie.

Landmarks: Bobby's collar and bowl are in the Museum of Edinburgh and he has the most photographed statue in Scotland, outside Greyfriars Graveyard.

1915: *The 39 Steps* by John Buchan (1875–1940)

Buchan's *The 39 Steps* was first published by Edinburgh's *Blackwood's Magazine* and is partly set in the city. It is one of the earliest examples of the 'man-on-the-run' thriller, as well as one of the finest. The book achieved even more fame when Alfred Hitchcock turned it into an acclaimed film.

Landmarks: Buchan was a frequent visitor to Edinburgh and lodged at Abden House, reputed to be the inspiration for St Trinian's School in the novels of Ronald Searle.

1917: Wilfred Owen Meets Siegfried Sassoon

In 1917, poets Owen (1893–1918) and Sassoon (1886–1967) met while convalescing at Craiglockhart Hospital. Owen was encouraged by his doctor to write for the hospital

magazine and began to produce poems, guided by Sassoon. Between them, they created a body of work that brought home the horrors of the First World War in graphic detail, catapulting both to international fame. They then came across the third great war writer, Robert Graves (1895–1985), at Baberton Golf Club in Juniper Green – quite possibly the most powerful meeting of English literary poets in the twentieth century. Graves went on to write classics such as *I Claudius*, while Sassoon reluctantly returned to the front and survived being shot in the head. Owen also returned to active duty and was killed a week before Armistice was declared.

Landmarks: Craiglockhart is now part of Napier University, while Baberton is still a golf club.

1918: *The Return of the Soldier* by Dame Rebecca West (1892–83)

Dame Cicily Isabel Fairfield was better known as Rebecca West. Her debut novel *The Return of the Soldier* helped define the condition now known as post-traumatic stress disorder, but it is West's life that made her such an influential figure. Described by *Time Magazine* as 'indisputably the world's number one woman writer', she reported on the Nuremberg trials, wrote several novels, had a son with H. G. Wells (1866–1946) and affairs with Charlie Chaplin (1889–1977) and Lord Beaverbrook (1879–1964).

Landmarks: West was educated at George Watson's Ladies' College in Merchiston and wrote about her friends the Mackenzie family who lived at No. 41 Heriot Row.

1926: *A Drunk Man Looks at the Thistle* by Hugh MacDiarmid (1892–1978)

The poet Christopher Murray Grieve (Hugh MacDiarmid) wrote in 'Synthetic Scots' – a version of the language that he constructed from dictionaries and local sources. Rather than seeming counterfeit, it was a bold way of taking disparate dialects and turning them into art. It reflected a new boldness in Scots writing, that was taken to its logical conclusion by his pal Sorley MacLean, who wrote in Gaelic.

Fun Fact: MacDiarmid lived at Brownsbank Cottage, Biggar. For a decade it had no electricity, kitchen, bathroom or running water.

Landmarks: MacDiarmid attended Broughton Junior Student Centre, taught at Broughton Higher Grade School and frequented Milnes Bar, the Abbotsford Pub, the Café Royal and the Oxford Bar. He is commemorated in Makars' Court, outside the Writers' Museum.

1929: *My Best Scotch Stories* by Sir Harry Lauder (1870–1950)

Lauder is a hero of mine and people forget that he wrote several books. He is better known as an entertainer, who wrote and performed perennially popular songs such as 'Roamin in the Gloamin', 'The End of the Road' and 'I Love a Lassie'. By 1911 Lauder had

become the highest-paid performer on the planet and was the first British artist to sell a million records.

Unfortunately, his portrayal of a tight-fisted Scotsman was so popular, that the nation's reputation for meanness persists to this day. The sad irony is, Lauder was the epitome of generosity, raising vast amounts of money for the troops during the First World War.

1936: The Saltire Society Founded

This was begun in Fountain Close, to promote and celebrate the uniqueness of Scotland's heritage. It still organises lectures and presents a series of awards for art, architecture, literature and history.

1943: *Dàin do Eimhir agus Dàin Eile* by Sorley MacLean (1911–96)

MacLean was one of the major modern Scottish poets, who brought Gaelic verse into the modern era and achieved international renown. Nobel Prize Laureate Seamus Heaney (1939–2013) credited MacLean with saving Scottish Gaelic poetry from obscurity.

Landmarks: MacLean studied at the University of Edinburgh and Moray House Teachers' Training College, where he met Hugh MacDiarmid. He also taught at Boroughmuir High School.

Moray House, where Sorley Maclean met Hugh MacDiarmid. (JH)

1943: *Far Cry* by Norman MacCaig (1910–96)

Norman Alexander MacCaig wrote in sparse, witty, plain-spoken English, but his poetry drew on the Highland landscapes and Gaelic culture he loved. His work observed urban poverty, slums, and overcrowding in Edinburgh.

Landmarks: MacCaig was born at No. 15 East London Street and lived at No. 7 Leamington Terrace. He was educated at the Royal High School, spent a year at Moray House Teachers' Training College and taught at Boroughmuir High School. He was appointed Edinburgh University's first Writer in Residence in 1967.

1947: *Whisky Galore* by Compton Mackenzie (1883–1972)

Described by Henry James (1843–1916) as 'the most promising novelist of his generation', Mackenzie joined a group of expatriate writers that included D. H. Lawrence, Somerset Maugham and Maxim Gorky, before returning to Scotland and becoming best buds with Hugh MacDiarmid. He then wrote the screenplay for the celebrated adaptation of his book, one of the best-known 'Ealing Comedies' and still a family favourite. Ignore the rubbish remake.

Fun Fact: Mackenzie's talents went far beyond writing. He was an actor, soldier, government spy, political activist, journalist, cultural commentator, raconteur and a co-founder of the National Party of Scotland (forerunner of the SNP).

Landmarks: Mackenzie lived at No. 31 Drummond Place.

1948: *Under the Eildon Tree* by Sydney Goodsir Smith (1915–75)

Born in New Zealand and educated in England, Smith adopted a Scots vernacular after listening to conversations in Edinburgh – and used it like a master. His long poem *Kynd Kittock's Land* celebrates the two sides of the city.

Drummond Place.

The hauf o't smug, complacent ... the tither wild and rouch as ever...

Known as 'The Auk', Smith became one of the leading lights of the thriving Edinburgh literary scene in the 1950s and 1960s.

Landmarks: Smith lived at No. 25 Drummond Place and No. 50 Craigmillar Place. He died in the Royal Infirmary of Edinburgh (after a heart attack outside a newsagents on Dundas Street) and is buried in Dean Cemetery. He frequented the Oxford Bar, the Abbotsford Pub and Milnes Bar.

Other Works of Note

1924: *The Problem of Atlantis* by Lewis Spence (1874–1955)
Lewis Spence was a poet and editor of the *Scotsman* newspaper, who wrote in classical Scots and was another founder of the Scottish National Party. He was also a respected folklorist, who penned many works on the occult. (His books on the origins of Atlantis gained a cult following.) His work inspired the little-known Russian Immanuel Velikovsky (1895–1979), who has a fanatical readership and is well worth checking out. Spence lived at No. 34 Howard Place and is buried in Dean Cemetery.

1930: *The Girl Who Did Not Want to Go to Kuala Lumpur* by James Bridie (1888–1951)
Author Osborne Henry Mavor (James Bridie) also wrote for the *Scotsman* newspaper, worked on several screenplays with Alfred Hitchcock and was instrumental in the establishment of the Edinburgh Festival. I picked this book because it has one of the most awesome titles ever.

1934: Up the Noran Water by Helen Cruickshank (1886–1975)
Helen Burness Cruickshank was a suffragette and a leader of the 'Scottish Renaissance'. This was a version of modernism which combined a heady mix of philosophy, technology and folk influences, and helped reawaken a spirit of cultural nationalism. She was an executive officer for the Department of Health in Edinburgh and a founding member of the Saltire Society. She lived in Corstorphine and has a plaque in Makars' Court.

1935: *We Have Been Warned* by Naomi Mitchison (1897–1999)
Shrugging off female stereotypes, Mitchison was a feminist, socialist, birth-control advocate and anti-nuclear campaigner, who had an open marriage and was friends with W. H. Auden, Stevie Smith, Doris Lessing, Aldous Huxley and E. M. Forster. *We Have Been Warned* (written after a trip to Russia) tackled taboo subjects like rape, contraception and abortion. She was born at No. 10 Randolph Crescent in the New Town.

1939: *The Novel and the Modern World* by David Daiches (1912–2005)
Daiches co-edited the behemothic *Norton Anthology of English Literature* and edited *The Penguin Companion to Literature*. As well as poetry, he wrote works on Virginia Woolf,

Robert Louis Stevenson, Robert Burns, D. H. Lawrence, John Milton, Sir Walter Scott, Bonnie Prince Charlie, Scotch whisky, the King James Bible, Edinburgh and Glasgow.

He studied at George Watson's College and the University of Edinburgh. He is buried in Piershill Cemetery.

1942: *The Last Enemy* by Richard Hillary (1919–43)

This best-seller is regarded as one of the all-time classic books about the Second World War. A pilot with the 603 (City of Edinburgh) Squadron, Hillary survived horrific burns after bailing out of his burning aircraft. A superb writer, he would have gone on to great things but was killed when his bomber crashed during a training exercise. 603 Squadron was located at RAF Turnhouse.

1948: *The Key to World History* by Comyns Beaumont (1873–1956)

William Comyns Beaumont wrote several books propounding completely nutty theories, which mirror those of Immanuel Velikovsky. But his wildest was the idea that Jesus had been crucified just outside Edinburgh, which was actually the Biblical city of Jerusalem. Check him out.

1942–47: *Elegies for the Dead in Cyrenaica* by Hamish Henderson (1919–2002)

As well as writing respected poetry, Henderson lived for long periods with travelling people, collecting old Scottish songs, ballads and stories to save them from obscurity. He turned down an OBE in protest at the Thatcher government's nuclear arms policy. His favourite haunt was Sandy Bells Pub, No. 25 Forrest Road, and he has a bust at South Gyle.

1951: *Jezebel's Dust* by Fred Urquhart (1912–95)

Much admired by George Orwell, Urquhart wrote hard-hitting novels and short stories. He was also a scout for Walt Disney and read scripts for Metro-Goldwyn-Mayer. Born at No. 8 Eglinton Crescent, he moved to Granton and attended Broughton Secondary School. He died in Musselburgh.

10. Late Twentieth Century: All Fur Coat and No Knickers

By the second half of the twentieth century, Edinburgh had comfortably settled into its role as a cosmopolitan, slightly bohemian, massive tourist destination, with beautiful architecture, stunning views and a rich history. This was a city representing a country beginning to see itself as all things to all men. And why not? As the famous saying goes, 'When truth becomes legend, print the legend.'

The astonishing rise of Edinburgh as a world leader and its intellectual legacy was real enough, and a justified source of pride. The wild romance of the Highlands, the epic story of Bonnie Prince Charlie and the fate of the doomed Jacobites was too alluring to mess with. We wanted to look back on the pastoral splendour of a lowland past, and the charming tales of Scotland's canny but friendly inhabitants, rather than dwell on the grinding hardships that had actually existed. The dark side of a fantastical city, known for being a hotbed of supernatural activity, drew people from all over the globe – so why not accept all that too?

All this stemmed from the pens of its writers, or those who were beguiled by the place. The truth had indeed become legend and nothing would shake that.

With a job well done, late twentieth-century authors found a new sense of confidence, so their works show a willingness to be more critical and hard-hitting – to uncover the flaws Edinburgh always tried to hide.

Mind you, we've never fooled Glasgow, which has a phrase brilliantly describing their rival city: 'All fur coat and no knickers.'

1961: *The Prime of Miss Jean Brodie* by Muriel Spark (1918–2006)
Time Magazine listed this short and sparse novel as one of the 100 best English-language novels from 1923 to present. It presents the self-absorbed downside of Edinburgh's intellectual legacy, in the formidable form of uncompromising teacher Jean Brodie.

Fun Fact: Spark was famous for composing her works in single draft with very few corrections, in spiral-bound school notebooks from the Edinburgh stationer James Thin.

Landmarks: Spark was born in No. 160 Bruntsfield Place, attended James Gillespie's School (the model for the Marcia Blaine School in *The Prime of Miss Jean Brodie)*. Brodie herself was based on a teacher called Christina Kay, who lived at No. 4 Grindlay Street and died in 1951, blissfully unaware she would soon be immortalised in print. Probably a good thing.

1963: Founding of the Traverse Theatre
The Traverse commissions and develops works from contemporary playwrights, as well as adaptations, dance, physical theatre, puppetry and contemporary music. It is located at No. 10 Cambridge Street.

Traverse
Theatre.

1964: *The Scientific Papers of Professor Tom W. B. Kibble* (1932–2016)

And another giant emerges. Kibble was a theoretical physicist who helped change the face of science, by co-discovering the Higgs mechanism and Higgs bosun – the 'God Particle'. I won't go into details because, though the subject fascinates me, I'm simply not qualified to do it so. Let's just say it was a very big deal and proved Edinburgh wasn't finished changing the world.

Fun Fact: The Physical Review Letters recognised Kibble's paper on Symmetry Breaking as one of the milestones in its history and Nobel Laureate Peter Higgs complained that Kibble should have been chosen to share the prize with François Englert and himself. If that wasn't enough, one of Kibble's later papers introduced the concept of 'cosmic string theory'.

Landmarks: Kibble was educated at Melville College and the University of Edinburgh.

Melville College.

1964: *The Steps to the Empty Throne* by Nigel Tranter (1909–2000)

Nigel Tranter was one of the world's foremost proponents of the historical novel, impeccably researched and vividly written. An expert on Scottish castles, he was closely involved in the restoration of over sixty.

Fun Fact: Tranter also wrote a slew of westerns, which he claimed took six weeks each to finish. He was also Scotland's Chancellor of the Order of Saint Lazarus, founded by Crusaders around 1119.

Landmarks: He lived in East Lothian and was educated at George Heriot's School.

1972: Opening of the Netherbow Arts Centre on the Royal Mile

The Netherbow incorporates the Scottish Storytelling Centre and, behind it, is Hope's Close, home of the Scottish Book Trust – a national charity promoting literature, reading and writing in Scotland.

Scottish Book Trust
Garden, Royal Mile.

Tweeddale Court, Canongate.

1973: Canongate Books Founded

Many independent publishers sprang up in Edinburgh during the twentieth century, of which Canongate is the most renowned. Their greatest success to date is Yann Martel's *Life of Pi*. When nobody else seemed interested, Canongate turned it into the best-selling Booker Prize winner of all time.

Fun Fact: Edinburgh is now home to over fifty publishing houses. No mean feat for a city with a population of less than 500,000.

Landmarks: Canongate operates out of Tweeddale Court on the Royal Mile.

1978: *The Slab Boys* by John Byrne (b. 1940)

As well as having a wonderful ear for dialogue, playwright John Patrick Byrne is a talented artist and designed record covers for Donovan, The Beatles, Gerry Rafferty and Billy Connolly.

Fun Fact: *The Slab Boys* first Broadway production starred Kevin Bacon, Sean Penn, Val Kilmer and Jackie Earle Haley.

Landmarks: Byrne attended Glasgow and Edinburgh Art Schools and can often be seen wandering around Tollcross, easily recognised by his magnificent white pointy beard. The play premiered at the Traverse Theatre, Edinburgh.

Bedlam Theatre, George IV Bridge.

1980: The Bedlam Theatre Founded

Originally the New North Free Church, built in 1849, near the site of the Bedlam Mental Institute on George IV Bridge. It is the oldest student-run theatre in Britain.

1983: Founding of the International Book Festival

Taking place every August in Charlotte Square, this is the largest festival of its kind in the world, part of the Edinburgh Festival and Fringe – the planet's largest celebration of the arts.

1984: *The Wasp Factory* by Iain Banks (1954–2013)

Once again, the sinister side of Edinburgh writing raises its head. Better known for sci-fi (under the name Iain M. Banks), I regard *The Wasp Factory* as his masterpiece. It's an immensely creepy horror novel, with a twist ending you should see coming, but don't – until it hits you like a jolt of electricity. *The Irish Times* called it 'a work of unparalleled depravity'. Sounds like a fine accolade to me.

Fun Fact: The asteroid 5099 is now called Iainbanks and Elon Musk named two of the company's autonomous spaceport drones after ships from Banks' novels.

Landmarks: Banks was born in North Queensferry (just outside Edinburgh) and eventually returned there to live.

1984: The Scottish Poetry Library Founded

Begun by the poet Tessa Ransford (1938–2015), the library houses some 30,000 items of Scottish and international poetry. Even better, it's free to the public. It is situated in Crichton's Close.

The Oxford Bar, Young Street.

1987: *Knots and Crosses* by Ian Rankin (b. 1960)

The first of the multi-million-selling *Inspector Rebus* novels, about a downbeat Edinburgh detective, these books positively revel in revealing the city's violent underbelly.

Fun Fact: Rankin was a member of the punk band the Dancing Pigs.

Landmarks: Rankin attended the University of Edinburgh and famously hangs out in the Oxford Bar, Young Street (also Rebus's favourite haunt). Rebus operates out of the police station in Gayfield Square and both Rankin and Rebus live in Arden Street.

1987: *Madame Doubtfire* by Anne Fine (b. 1947)

The second British Children's Laureate, multi-award-winning Fine lived in Edinburgh for several years, and used to pass a second-hand clothing shop called Madame Doubtfire on the corner of South East Circus Place. Doubtfire would often sit outside greeting passers-by and she stuck in Fine's mind. The result was her most famous novel, later turned into the movie *Mrs Doubtfire*, starring Robin Williams.

Fun Fact: Fine is wholeheartedly against labelling children's books as 'for boys' and 'for girls', which makes her a bit of a goddess in my eyes.

The Banana Block, Leith.

1993: *Trainspotting* by Irvine Welsh (b. 1958)

Irvine Welsh is the bad boy of modern Scottish literature, often writing in an Edinburgh dialect. His debut novel achieved worldwide cult status, as did the Danny Boyle film of the same name.

Fun Fact: Like Ian Rankin, Welsh played in punk bands *The Pubic Lice* and *Stairway 13*.

Landmarks: Welsh was born in Leith before moving to Muirhead housing estate. He went to Ainslie Park High School, now the North campus of Telford College. *Trainspotting* features the brutalist hi-rise Cables Wynd House, better known as the Banana Block because of its curved shape, and its characters drink in the Volunteer Arms (now the Cask and Still) and the Central Bar. Welsh himself frequented the Boundary Bar (now City Limits). The book's ironic title refers to the defunct Leith Central station, a symbol of the lack of attention paid to the area.

1997: *Harry Potter and the Philosopher's Stone* by J. K. Rowling (b. 1965)

At the end of the twentieth century, Edinburgh produced another world-changing author. The Harry Potter novels of Joanne Rowling have currently sold more than 500 million copies, becoming the best-selling series of all time. Rowling was voted the most influential woman in Britain. I regard her as the author who finally demolished the dividing line between children's and adult novels – about time too. I've seen the lines outside bookstores, waiting to buy her latest release, and none of them were kids.

Landmarks: Rowling wrote parts of the novel in the Elephant House Café on George IV Bridge, overlooking Candlemaker Row and Greyfriars Graveyard. Though she denies it,

Right: Tom Riddle's
grave, Greyfriars.

Below: Elephant
House café,
George IV Bridge.

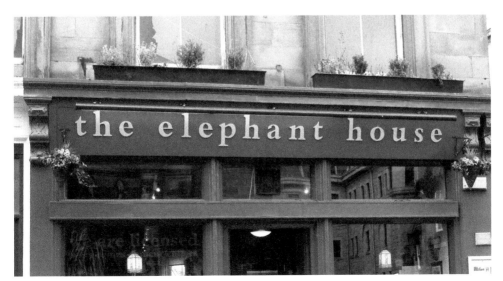

I'm convinced Candlemaker Row (which used to contain a witchcraft shop) is Diagon Alley and Heriot School (right across from the café window) is Hogwarts. There's also a gravestone in Greyfriars inscribed with the name Tom Riddle (Voldemort's real name) and a plaque to the poet McGonagall.

1998: *The No. 1 Ladies' Detective Agency by* Alexander McCall Smith (b. 1948)

McCall Smith is Emeritus Professor of Medical Law at the University of Edinburgh and an expert on bioethics. He is also the best-selling author of over 40 million books, translated into almost fifty languages. His celebrated *44 Scotland Street* books paint a vivid portrait of life in the modern New Town.

Fun Fact: McCall Smith is an amateur bassoonist and co-founder of the wonderfully titled 'Really Terrible Orchestra', set up for people without the talent or experience to be in a professional body. He also helped found Botswana's first centre for opera training and wrote the libretto for their first production, a version of *Macbeth* set among a troop of baboons.

Landmarks: McCall Smith lived for many years in Morningside. The Cumberland Bar is immortalised in his novel *44 Scotland Street*, as a typical New Town drinking

No. 43 Scotland Street.

establishment. There's no point in looking for 44 Scotland Street, though; the numbers stop at 43.

Other Works of Note

1975: *Two Men and a Blanket* by Robert Garioch (1909–81)
Born and raised in Edinburgh, Garioch's poetry was written in Scots and was instrumental in the literary revival of the language during the twentieth century.

1961: *Game of Kings* by Dorothy Dunnett (1923–2001)
Dunnett is famous for the Johnson Johnson detective books and House of Niccolò and Lymond Chronicles historical novels, of which *Game of Kings* was the first. She lived at No. 87 Colinton Road and attended James Gillespie's High School for Girls.

1969: *A Time to Keep* by George Mackay Brown (1921–96)
One of the great Scottish poets of the twentieth century, his verse was so internationally renowned the American poet Robert Lowell came to Scotland for the sole purpose of meeting him. Brown attended Edinburgh University, Moray House teacher training college and drank in Milnes Bar with Sydney Goodsir Smith, Norman MacCaig and Hugh MacDiarmid. This didn't do him any favours, as he was an alcoholic.

1970: *The Twelfth Day of July* by Joan Lingard (b. 1932)
Lingard has written adult novels, but *Twelfth Day of July* is the first of her acclaimed 'Kevin and Sadie' series of young adult books. Despite the controversial subject matter (the Northern Ireland Troubles), they have sold over a million copies. She was born on the Royal Mile and still lives in Edinburgh.

1984: *The House by the Dvina* by Eugenie Fraser (1905–2002)
At eighty years old, Fraser took a creative writing class, then published her autobiography. It tells the story of her childhood in Archangel, during the Russian Revolution – a valuable first-hand account of a time stricken from history by the Bolsheviks. She fled in 1920, leaving behind a father she never saw again and family members who were imprisoned or executed. She lived quietly in No. 5 Braid Crescent, among neighbours who had no clue about her past.

1993: *Skinner's Rules* by Quintin Jardine (b. 1945)
A prolific best-selling crime writer and rival to Ian Rankin, Jardine's Bob Skinner is an unorthodox Edinburgh detective who made his first appearance in Advocate's Close on the Royal Mile.

1994: *Just Whores* by Anita Sullivan (b. 1971)
This was the first of over sixty plays by award-winning writer Anita Sullivan. She lived at No. 83 Haymarket Terrace, where I was her flatmate – but that's not why I included her. I did it because she's brilliant.

Anita Sullivan.

1995: *The Matrix* by Jonathan Aycliffe (b. 1949)

The pen name of Denis M. MacEoin, Aycliffe attended the University of Edinburgh, and this Faustian chiller is another horror set in the city.

1996: *Quite Ugly One Morning* by Christopher Brookmyre (b. 1968)

This Edinburgh-set 'Tartan Noir' is one more novel that revels in exploring the nasty side of the city.

1998: *Batman: Scottish Connection* by Alan Grant (b. 1949)

The caped crusader gets mixed up with his Edinburgh relatives in this imaginative graphic novel. Holy highland cow, Batman!

11. Twenty-first Century: What Next?

It's too soon to tell what the future holds, though it looks like the city's literary community is still going strong. Here's hoping the next chapter is as exciting as the ones that have already graced the pages of history. Looks promising, however.

2000: *The Fanatic* by James Robertson (b. 1958)

A fitting book to start the new century, as it comes pretty much full circle to where everything kicked off. *The Fanatic* tells the story of a modern-day Edinburgh ghost tour guide, whose research leads to an obsession with the Covenanter James Mitchel, and the disgraced minister Thomas Weir, burned for witchcraft.

Landmarks: Robertson got his PhD at the University of Edinburgh and worked at Waterstones bookstore. Unsurprisingly, Edinburgh is famous for its ghost tours and I even own one – City of the Dead.

2004: Edinburgh becomes the UNESCO City of Literature

There are now almost thirty Cities of Literature all over the world, but we were the first. 'Nuff said.

2019: *Hide* by J. A. Henderson (b. 1962)

Jan-Andrew Henderson is one of Edinburgh's most underrated writers, in my opinion, but that's probably because it's me.

J. A. Henderson

Landmarks: Jan-Andrew Henderson founded the City of the Dead ghost tour, which starts outside St Giles' on the Royal Mile. He lived at No. 10A and No. 62 Great King Street, No. 20 Candlemaker Row, No. 10 Thirlestane Lane and No. 20 Gardner's Crescent before emigrating to Australia. That's a tour in itself.

Other Works of Note

2003: *The Da Vinci Code* by Dan Brown (b. 1964)
Selling over 80 million copies and translated into fifty-seven languages, this epic turned Roslyn Chapel, just outside Edinburgh, into a major tourist destination. It also reignited interest in Scotland's connections to the Knights Templar and the Holy Grail (which is reputed to be buried in a vault there).

2007: *The Most Wonderful Thing in the World* by Vivian French (b. 1945)
Vivian June Isoult French has written more than 250 best-selling children's books and is a tutor in the illustration department at Edinburgh College of Art.

There you have it. Did literary Edinburgh change the world?

Well, all events do. It's called the butterfly effect – the idea that small things can have huge impacts on a complex system, like the flapping of an insect's wing causing a tsunami.

Roslyn Chapel.

But Edinburgh didn't produce small things. A tiny city with huge ambitions, it created its own tidal wave of ideas, influences and events. The question is, can it continue to do so?

I believe it can. This is where Scotland's age-old ability to reinvent itself will serve us well. As I write, the world seems to be heading for an era where rampant nationalism threatens the idea of a global community. Scotland's reinvigorated push for independence, however, stands out as a shining example – a nationalism that is inclusive and welcoming to other countries. That chip on our shoulder has turned out to be a great thing, for it allows us to buy into our own myths, and we can't do them justice without being forward-thinking, responsible citizens of the globe.

So, in a way, we are world leaders once more. Morally this time, which is what really counts. Will our literature reflect that and point the way forward?

I hope so.

Bibliography

Ainslie, John, *City of Edinburgh* (1780)

Arnot, Hugo, *The History of Edinburgh* (West Port Books)

Birrell, J. F., *An Edinburgh Alphabet* (Mercat Press, Edinburgh, 1980)

Books of the Old Edinburgh Club (Vols I to present)

Brown, Ed, and Iain Gordon, *Elegance and Entertainment in the New Town* (Rutland Press, 1995)

Buchanan, George, *The History of Scotland* (Churchill, 1690)

Campbell, R. H., *Scotland since 1707* (Oxford, 1977)

Chambers, R., *Domestic Annals of Scotland* (1858)

Chambers, Robert, *Traditions of Edinburgh* (London, 1824)

Christie, William, *The Edinburgh Review in the Literary Culture of Romantic Britain* (London, Pickering & Chatto, 2009)

Cockburn, Henry, *Memorials of his Time* (1856)

Daiches, David, *Edinburgh* (Granada Publishing, 1978)

Dawson, Jane E. A., *Oxford Dictionary of National Biography* (Oxford University Press, 2004)

ed, Lynch, Michael, *The Oxford Companion to Scottish History* (Oxford University Press, 2001)

Edinburgh and Places Adjacent, 1580-1928 (National Library of Scotland)

Ellis, Havelock, *A study of British Genius* (Boston, 1926)

Foster, Allan, *The Literary Traveller in Edinburgh* (Mainstream, Edinburgh 2005)

Geddy, John, *Romantic Edinburgh* (1921)

Gilbert, W. M., *Edinburgh in the Nineteenth Century* (Edinburgh, 1901)

Gillon, J. K., *Eccentric Edinburgh* (Moubray House Publishing)

Goring, Rosemary (ed), *Chambers Scottish Biographical Dictionary* (Edinburgh, 1992)

Grant, James, *Cassell's Old and New Edinburgh* (London: New York: Cassell, Petter, Galpin & Co., 1881)

Herman, Arthur, *The Scottish Enlightenment* (Fourth Estate, London, 2001)

Holinshed, *Chronicles of England, Scotland and Ireland* (London, 1577)

Keay, John and Julia (eds), *The Collins Encyclopaedia of Scotland* (Harper Collins, 1994)

Keir, David, *The City of Edinburgh, The Third Statistical Account of Scotland*

Lee, Sidney (ed), *Dictionary of National Biography* (London: Smith, Elder & Co., 1893)

Littlejohn, Henry, *Report on the Sanitary Condition of the City of Edinburgh* (Edinburgh, 1863)

Lochhead, Marion, *Edinburgh Lore and Legend* (St Edmundsbury Press, 1986)

Mackie, J. D., *A History of Scotland* (New York, 1964)

Maitland, W., *A History of Edinburgh*

Minto, C. S., *Edinburgh, Past and Present* (Oxford Illustrated Press)

Pope, James, *Robert Louis Stevenson* (1974)

Royal, Trevor, *Precipitous City* (Mainstream Publishers, Edinburgh, 1980)

Smith, Mrs J. Stewart (1924), *Historic Stories of Bygone Edinburgh* (T & A Constable Ltd)

Smith, Robin, *The Making of Scotland* (Canongate Books, 2001)

Steel, Tom, *Scotland's Story* (Collins, 1984)

Stevenson, Robert Louis, *Picturesque Old Edinburgh* (Albyn Press, 1983)

Watt, Francis, *The Book of Edinburgh Anecdotes* (London, 1913)

Wills, Elspeth, *Scottish Firsts* (Scottish Development Agency, Glasgow, 1985)

Youngson, A. J., *The Companion Guide to Edinburgh and the Borders* (Polygon Books, Edinburgh, 2001) *The Making of Classical Edinburgh* (1966)

About the Author

Jan-Andrew Henderson is the author of the non-fiction books *The Old Town: A Comprehensive Guide*, *The Town Below the Ground: Edinburgh's Legendary Underground City*, *The Emperor's New Kilt: The Two Secret Histories of Scotland*, *The Ghost That Haunted Itself: The Story of the Mackenzie Poltergeist*, *City of the Dead*, *Black Markers*, *The Royal Mile: A Comprehensive Guide* and *Edinburgh New Town: A Comprehensive Guide.* He is also a novelist, who has been short-listed for thirteen literary awards and the winner of the Royal Mail and Doncaster Book Prizes.

www.janandrewhenderson.com